The Advent of a Christmas Season

ELIZABETH ELIUK

The Advent of a Christmas Season

Copyright © 2017 Elizabeth Eliuk

None of the designs in this book may be reproduced commercially
without obtaining permission from the author.

All Rights Reserved. No part of this book may be reproduced or stored
in a retrieval system or transmitted by any means, or photocopied,
without the expressed and prior permission of the author.

ISBN 978-1981394128

Also by Elizabeth Eliuk:

Tapestry of Florals: an artist's perspective
ISBN 978-1539917427 • www.CreateSpace.com/6694433

Published in November of 2016, this book was illustrated based and adapted from the author's original paintings. The designs are large and unlike my subsequent books, which are highly complex designs, the images in *Tapestry of Florals* offer simpler drawings which are large and depict what one would find in nature. It is an excellent starting point for colourists who prefer to colour simpler designs or who wish to add their own details.

Five-star reviews at Amazon:

★★★★★ "Very well organized and absolutely beautiful! The designs are very ornate, detailed, and lots of fun coloring these beautiful designs." —*kstars*

★★★★★ "This is a beautiful coloring book. One of the best ones that I have ever colored!" —*a*

★★★★★ "The designs are beautifully scaled with detailed illustrations that can be colored intricately or simply depending on your personal coloring style." —*Amazon Customer*

Find Calm in the Garden of Paradise
ISBN 978-1974525737 • www.CreateSpace.com/7462296

Published in August 2017, it was designed keeping in mind the more advanced colourists or those who prefer highly detailed illustrations. Inspired by the Arts and Crafts pioneer William Morris, during the 19th century in the UK, colourists will discover 25 images, ranging from novice levels with less complex designs to ones that a more experienced colourist would enjoy. The book also includes hints on how to use the book, tools that are best to colour with, and an art lesson encompassing the basic concepts of the colour wheel and colour theory.

More five-star reviews at Amazon:

★★★★★ "Quality from cover to cover. This book offers so much more than a coloring pastime.... Well worth the price and I look forward to her next issue." —*Emily A Wiles*

★★★★★ "I loved this book. A great way to spend time relaxing and using your talents to create beautiful artwork. Well done, Elizabeth!" —*Amazon Customer*

I hope you will enjoy *The Advent of a Christmas Season* and will find it feasible to purchase and have fun with the other editions as mentioned above. Be sure to look for my new *Designer* publications in 2018.

Merry Christmas. —Elizabeth Eliuk, artist, illustrator and author.

Graphic design by Ingénieuse Productions
Edmonton, Alberta, Canada

The Advent of a Christmas Season

To colour your own winter wonderland Tapestry and create your own personal and memorable holiday stress-free perspective

Elizabeth Eliuk

www.facebook.com/people/Elizabeth-Eliuk/100011777359791

www.artwanted.com/artist.cfm?ArtID=85552

www.amazon.com/author/elizabetheliuk

BLOGS
dashingdiva.blog
dashingdivadot.blog
diva9775.wordpress.com
diva377.wordpress.com

TAPESTRY: AN ARTIST'S PERSPECTIVE
www.facebook.com/emeliuk.art

E-MAIL
eliukelizabeth@gmail.com

Acknowledgements

Like most successful endeavours, this book involves the effort of several individuals.

I would like to take this opportunity to say "thanks" to the graphic specialists who formatted this book, Ana Anubis and David Macpherson of Ingénieuse Productions. Any errors are the fault of the author. Their advice on the technical aspects, support, and excellent sense of humour were well received and appreciated.

My love and gratitude to my husband Ray, who has to put up with my odd hours and has always been my champion, supporting and applauding my dreams, aspirations, and efforts.

We are most fortunate to have friends in our lives and I have had the privilege of knowing far too many to mention here. All your encouragement, honest opinions and suggestions have proven invaluable. I thank all of you from the bottom of my heart.

And last, but not least, to my multitude of 'furbabes', always at my side, offering me love, affection, and silent support ... love, hugs, and kisses to all twenty of you.

—E.E.

Contents

Preface . vi
A Mini Art Lesson . vii
Hints for Colouring Glass, Drops, and Snow ix
Using This Book . x
The Colour Wheel . xi

LEGENDS

The Legend of the Candy Cane 1
Legend of the Christmas Rose 2
Legend of the Cardinal 2
Legend of the Evergreen Tree 3
The Legend of the Nutcracker 3
The Legend of the Robin 4
Legend of the Babushka 4
Legend of the Christmas Spider 5
The Legend of the Sage Plant 6
The Legend of Rudolph 6

The Legend of the Holly 7
The Legend of Santa Claus 8
The Legend of the Drummer Boy 8
The History & Traditions of Advent . . . 9
The History and Legend
 of the Amaryllis 10
History of the Feather Tree 11
The Twelve Days of Christmas 11
Boxing Day, December 26 12
Legend of the Mistletoe Bride 13

DESIGNS
Find the hidden candy canes!

1. Designation page:
 Personalize your Book.
2. A Star Is Born
3. Winter Wonderland
4. All Dressed Up
5. Trinity
6. Christmas ... Where the Home Is
7. A Framed Ornament
8. Partridge in a Pear Tree
9. Oh Christmas Tree
10. Christmas Buddies
11. On Its Way
12. Majesty of the Winter Woods

13. Distributing the Goods
14. Frosty Companions
15. Christmas Siblings
16. A Message from the Cardinals
17. Bells Will Be Ringing
18. Musical Chimes
19. Angels in Our Midst
20. Father Christmas
21. A Christmas Magnolia
22. The Legendary Christmas Rose
23. Ding Dong: a Christmas Song
24. Goodies Behind Glass
25. A "Sparkling Amaryllis"

v

Preface

Christmas is my favourite time of year, although in creating this book, it came somewhat earlier for me. And as I put the final touches on this edition, I realized that Christmas is just around the corner; how quickly the days pass, during the finest moments in one's life. A time for family and friends; a time of peace, joy and celebration anticipating that one day, December 25. But Christmas is more then one day on the calendar; it is a culmination of events during the entire month of December, a winter festival.

And so I bring to you this colouring book entitled *The Advent of a Christmas Season*!

Within its pages you will find illustrations reminiscent of an era when Christmas was less about gifts and more about the joy of giving and sharing. The whimsical and colourful greeting cards of the mid 20th century and beyond was my source of inspiration for the images I have created. And like *Tapestry of Florals* and *Find Calm in the Garden of Paradise*, all the designs were hand-drawn without any technological intervention or support. And as Christmas wouldn't be what it is without family, so too this colouring book is family-oriented. Everyone of all ages can join in the fun, searching for the candy cane that is hidden within each drawing.

An advent calendar, with the dates of December 1st to 25th inclusive, has been inserted after each design. Perhaps you may wish to write a favourite quote or write the great things that happened to you on each day or make note of the gifts that you received during advent, which is a tradition of the season. Or just relax and simply colour as each day approaches.

You will also find hints on how to colour a water droplet and ideas on what colours to use for the snowy landscapes; an art lesson and a colour wheel and its basic theories!

Included are the many legends of the season that have been passed down from one generation to another, since the birth of Christ and the inception of Christianity.

Each page awaits you and your entire family's pleasure and I hope you will enjoy what I found pleasure in providing for you, the colourist.

I would also like to take this opportunity to wish you and yours a happy, healthy and safe Christmas. And may all your dreams and aspirations come true in the coming New Year. I look forward to creating more books for you in the near future. Be sure to watch for my *Designer Series* beginning in the spring/summer of 2018.

Regards,

—Elizabeth Eliuk

A Mini Art Lesson

There are no rules to colouring except to relax, enjoy yourself, and have fun!

To guide you along the way, I've provided a few hints and instructions with the understanding that you, the colourist, can and should use the information provided as suggestions.

1. If you choose to use coloured pencils, which I recommend, deciding which brand is suitable can be daunting and confusing, considering the variety available in today's market.

 i. **Premier Prisma Coloured Pencils**: these are my favourite and are available in sets of 36, 72, 132, and 150. They are wax-based, providing a creamy-smooth, semi-opaque application. Because of their translucency, each subsequent layer is visible, allowing intermixing of colour in an endless variety. Prismas are the most economical, and like most brands can be easily obtained at your nearest art supply outlet. There is one drawback to wax-based pencils: after applying several layers, there will develop what is referred to as *wax bloom,* giving your work a dull appearance. This can be removed with a soft tissue and gently polishing the applied colour. A fixative designed specifically for coloured pencil can be used not only to seal and protect your work, but to eliminate wax bloom. My favourite brands are Krylon and Grumbacher workable fixative. "Workable" means you can spray a light coating and continue to add more layers of coloured pencil.

 ii. **Faber Castell Polychromos** are available in sets of up to 120 pencils. Unlike the Prismas, these possess an oil base. They also have a tendency to smear easily, and often the colour needs to be reapplied. Avoid this by working left to right (or right to left, depending on which hand you use).

 iii. **Derwent Colorsoft**: available in Student or Professional grades. These come in sets of up to 120. They have a more 'chalky' consistency but layer colours beautifully. They do not possess the Prismas' vibrancy of colour.

 iv. **Caran d'Ache Luminance** provide sets of up to 120. They are oil-based coloured pencils, light-fast and performing the same as the Faber Castell, but they cost considerably more.

 All these coloured pencils can be intermixed and used simultaneously.

2. For a pristine clear surface, place a paper towel, tracing paper, or simply another piece of paper under your hand as you work. This will prevent the transfer of oils from your skin to the paper and protect the areas already completed.

3. Use a soft brush (a paintbrush, for example) to sweep away any bits & pieces of pigment that may get deposited, especially after sharpening your pencil.

4. i. Always use your pencils with a sharp point. It is more feasible and economical to use a hand-held sharpener, as electric sharpeners tend to 'eat' your pencil.

 ii. The paper in this book is of an excellent quality and thickness, allowing for multiple layers of pencil. The sharper the point on your pencil, the easier it is to deposit and layer colour.

5. Keep in mind that the colour of the casing, or in the colour charts provided with some brands, may not accurately indicate the colour of each pencil.

6. If you layer more than one colour and are satisfied with the result, be sure to note the names of the colours used and their corresponding numbers, for your future reference.

7. Coloured pencils can be erased but will leave behind a blush of colour staining the paper. Use caution, as too much or too-heavy erasing will damage the texture of the paper. There are several battery-operated erasers available, but I have found the most efficient is manufactured by Staedtler. A *kneaded eraser* is handy for lifting colour to highlight an area, achieving a more three-dimensional effect.

8. Darken your colours by combining indigo rather than black or grey. This will give your work a 'freshness' and brilliance. The only exception is over yellow, as using a dark blue (indigo) with yellow will give you green. In this instance, use a neutral grey or its complement (see "The Colour Wheel").

9. Gel pens or markers can be used alone or in conjunction with coloured pencils. A word of caution: before applying any type of marker, place a sheet or two of paper underneath the page you are working on to prevent the colour from bleeding onto the next page. Whether you are using coloured pencils or gel pens, it would be to your benefit to insert a couple of untextured sheets of paper in between the pages, to avoid the possibility of the printer's ink being transferred to the underside of the page. The heavier the pressure applied by your pencil or pen, the greater the chances this may occur. There are several brands of gel pens and markers available. Experimentation and experience is not only enjoyable but the best teacher. Always wait for the gel pen or marker to dry before turning the page or closing the book.

10. Water-based products are not recommended, as they will cause the paper to buckle regardless of the thickness. Even specifically designed watercolour paper requires special preparation to avoid buckling from the use of water-based media.

11. Display your work in your home, or present your creation as a gift to someone special. Never display your work in direct sunlight.

Hints on How to Colour Glass
See Design #24, "Goodies Behind Glass".

1. Stay as true to your values (from light to dark and *vice versa*) and indicate your highlights, which in this case is the white of the paper.

2. Rounded glass containers tend to invert colour. So if your background is light at the top, then the glass will reflect the lightness at the bottom. The same holds true if your background is dark at the bottom: the glass will reflect that at the top.

3. Keep in mind that all glass has some colour and the darker colour reflected in the glass, along with the highlights, is what gives glass its sparkle.

4. Always keep your edges hard and defined. You can see reflections both on the inside and the outside, realizing that with glass you can see inside, outside and behind it as well. Any objects found behind glass are distorted.

Good luck and enjoy.

How to Colour a Drop of Water
Refer to visual demonstration below.

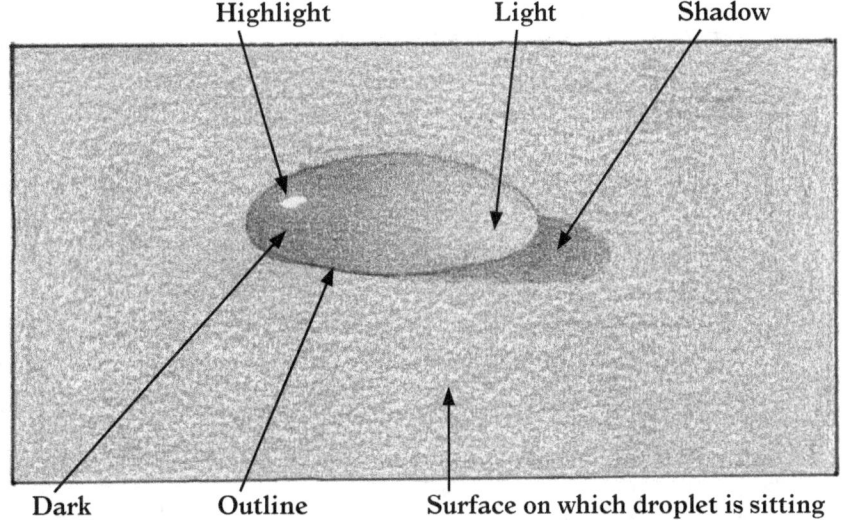

1. A drop of water is made up of all the colours of the surface it is sitting on. And it also acts as a magnifying glass.

2. The outline is always darker then the surrounding surface.

3. The highlight, which is created by the light source, is located within the darkest part of the drop.

4. As the surface moves away from the light source and the highlight, the drop of water becomes lighter.

5. The lightest part of the drop of water is always lighter then the surface it rests upon.

6. The shadow lies outside the lightest part of the drop of water and the furthest away from your light source.

Hints on How to Colour SNOW!

Snow is the atmospheric vapour frozen into ice crystals, resulting in falling white flakes.

Although a blanket of snow will not mirror objects the same as water does, it will reflect the colours of its environment in muted tones.

1. A clear blue sky with the sun shining will give you a light blue snow with tinges of cool yellow (see colour wheel), as highlights.

2. A cloudy grey sky will show snow with hints of grey blue and soft white with very little difference of tones in the snow.

3. A lovely evening sunset, allows the snow to appear with the same but muted tones reflected off the sky with marked highlights of the lightest colour and white.

4. If a night sky is filled with stars and moonlight, the snow will appear an icy pale blue and cool grey, with white stark highlights.

5. These are only a few of the examples of the colours you will find in a winter sky. Have fun imagining how you would colour your skies and snow in this Christmas colouring book.... Enjoy!

Using This Book

I hope you will find as much pleasure in this book as I have found in creating it.

The images in this book have all been designed keeping you, the colourist, in mind. Whether you are a novice or expert, or somewhere in between, I guarantee your satisfaction whatever your level of expertise.

There is a border around each design for more attractive framing. A "Designation" name page allows you to personalize this book by entering your name and the dates you started & finished. Pages titled "Notes / Reminders to Myself" are provided for your convenience at the back of this book.

If you enjoyed the book, I invite you to post your comments and examples of your artistry on my blog, dashingdiva.blog, or e-mail me at eliukelizabeth@gmail.com.

I look forward to hearing from you.

—E.E.

The Colour Wheel

Colour surrounds us everywhere, and how each of us sees and interprets colour is as unique as a fingerprint. Artists develop and utilize a 'personal palette' that they use consistently in all their work.

Colour is defined by three characteristics:

i. *hue* – the name of the colour,
ii. *value* – the lightness or darkness of the colour, and
iii. *intensity* – defined by the purity or strength of a colour: vivid or dull. "Dull" is not used pejoratively, only to describe it as being opposite of vivid.

The colour wheel will help you understand the basic concepts of colour and determine your own 'palette'.

Primary colours are the three basic colours from which all other colours are mixed, namely red, blue, and yellow.

Secondary colours are obtained by mixing two primary colours, for example orange or green.

Tertiary colours are obtained by mixing a primary and a secondary colour, for example yellow-orange or blue-purple.

Complementary colours are pairs that are positioned directly across the wheel from one another, for example red and green. Mixing the complementaries from your colour wheel will give you a grey.

Analogous colours are close together on the wheel and nearly alike, but slightly different in hue, for example yellow, yellow-green, and green.

Black and white are not considered colours because they have no range of values. White is never lighter or darker as black is neither darker nor lighter. White is to put it simply "white" and the same holds true for black.

But when you mix the black and white, you will get grey and depending on the proportions of each you will now achieve values. Therefore when you add white you create a *tint*, adding grey makes a *tone*, and black a *shade*.

The colour wheel is divided in half. The left side has the *warm* colours; the right side has the *cool* colours. Yellow and purple are on both sides of the wheel, because these colours can be either warm or cool.

ENVISION AND CREATE YOUR OWN PERSONAL COLOURIST'S PALETTE

A colour wheel has been purposely left blank of all colour, but providing the names of the hues in each category. It is left for you to choose your own colours and fill in the blanks, giving attention to the specified sections. Layer your primaries to give you the secondary / analogous / tertiary combinations as indicated in the legend below the colour wheel.

⟷ – Complementary

{ – Analogous

(only some examples shown)

P – Primary
S – Secondary
T – Tertiary

The Legends of Christmas

Christmas is not just a celebration on December 25th. It is the entire holiday season, the month of December, where we marvel and pay tribute to our beloved family and friends. A time to share the joy and the wonder of life, whether over a glass of wine, cup of hot chocolate or a deliciously cooked meal. The home is often invaded with the smells of baked cookies, spices that delight the senses, laughter over shared memories. A time for forgiveness, putting the unfortunate events in our past, behind us.

The snow glistens on the ground, inviting sleigh rides and numerous winter activities.

We all have many traditions to observe during this time depending on our cultural heritage. Many of these traditions stem from our ancestors so long ago. Stories are related and in most cases there is a lesson to be learned and observed.

You will find the following legends began since the Birth of Christ and the inception of Christianity over two millennia ago. Each legend is recounted in honour of good deeds, the sharing of bounty with others less fortunate and the reassurance that all goodness is acknowledged and rewarded. I hope you enjoy the following and that you will share these legends with your loved ones at a time when faith and hope is renewed.

Merry Christmas!

—Elizabeth Eliuk, Author.

The Legend of the Candy Cane

It all began 230 years ago. A German choirmaster was experiencing difficulty, controlling the unruly children during a nativity ceremony they were rehearsing. According to the church's rules candies of any form were forbidden within the confines of the cathedral. So in order to settle the children and conform to Christian doctrines the choirmaster formed the white candy into the shape of a staff, representing the sacred symbol of the shepherd Jesus Christ.

In 1847, a Swedish immigrant from Wooster, Ohio, strung the candy canes as decorations on the Christmas tree. The idea soon caught on and by 1900, candy canes sported red stripes, flavoured with cinnamon and peppermint.

The symbol of the "J" evolved into modern allegorical representation. The "J" stood for Jesus; the white represented the purity of Christ; and the red stripes were a reminder of the blood Jesus shed when he was whipped by the his captors, the Romans.

The flavouring of the candy cane is derived from Hyssop, which makes reference to the Old Testament, where hyssop is symbolic of sacrifice and purification.

Legend of the Christmas Rose

The Christmas Rose has come to symbolize hope, love and all the wonders of the season. And like so many items related to the holidays, the rose holds a special place in Christian folklore.

On a bitterly cold night in December, worshippers were flocking to see the New Saviour, bringing many beautiful gifts such as gold, Frankincense and myrrh presented by the three Wise Men.

Among the numerous visitors was a very poor shepherdess, who wished to see the Christ Child and searched in vain for flowers in the harsh dreary winter. In despair she wept helplessly upon seeing all the rich gifts.

An angel on high, watching over her, saw her sorrow and began brushing aside the snow at her feet. And where her tears had fallen there emerged beautiful white roses with petals tipped with soft pink. As gift giving comes from the heart, the angel whispered in her ear that her offering was far more significant then the richness of other gifts.

Encouraged by the angel's words, the shepherdess presented her bouquet of roses, reared with her tears to the Holy Infant, who in turn smiled with gratitude and appreciation.

Legend of the Cardinal

With its bright red plumage and loud insistent chirping, there is little wonder it is associated with messages from the spirits of our loved ones. Considered that it represents the doorway between two worlds, the name Cardinal is derived from the Latin word *cardo*, meaning a "hinge" as in a door, or axis. Our deceased loved ones, according to folklore, choose winged creatures to get our attention.

The cardinal has been designated in our modern world, as cardinal colours, using a representation of it during the Christmas season. We also have cardinal directions and four of the seven archangels, being Michael, Gabriel, Raphael and Uriel are known as Cardinal Angels.

It is easy to understand why there are so many wonderful associations with this cheerful and colourful bird. They mate for life; they are non migratory, remaining in one area where they live all year round, all their lives protecting their territory.

Both parents work together to raise their young to ensure a secure and healthy family unit.

If you are fortunate enough to sight one of these birds, ask yourself who and what were you thinking of at the time.

Were you perhaps seeking a solution to a vital question?

Inviting a sense of peace for being heard, guided and protected by the spirit, ensure that you thank them for the very guidance you are searching for.

Legend of the Evergreen Tree

There once was a little bird, flying away to the south from the cold and desolate winter, when she broke her wing and got left behind.

Cold, hungry, and despairing she asked the birch tree if she could shelter in her branches. The tree refused her request citing she had to look after all the other numerous birds in the forest.

The oak tree turned her away, as it feared the little bird would eat all the acorns. And the willow would not even acknowledge her, as it never talked to strangers.

Despondently, the little injured bird struggled to fly until a Spruce tree kindly offered her shelter within the softness and warmth of her branches.

Inspired by the benevolence of the Spruce, the Pine tree used its magnificent branches to protect the Spruce tree and the little bird.

The little juniper tree, not to be outdone offered food to stave off hunger, enabling the little bird to heal and fly off happily in the spring.

The Frost King had closely observed these activities and asked the north wind to never touch the leaves on the Spruce, Pine and juniper trees; they were to remain green for eternity, to repay them for their kindness.

The Birch, Oak and Willow tree would have their leaves plucked by the North wind, leaving them without protection, throughout the winter.

The Legend of the Nutcracker

Everyone is familiar with the ballet *The Nutcracker Suite* and its magical association with Christmas.

E.T.A. Hoffman first wrote the ballet in 1892, but was considered too morbid for children. Alexandre Dumas *Père* rewrote it with more joy and optimism.

The story revolves around a young girl whose uncle gifted her with a magical and mysterious Nutcracker. Enthralled with her gift she kept him by her side at all times.

One night while she was sleeping the evil Mouse King came to steal her away to his kingdom. The Nutcracker suddenly came to life and defeated him.

Clara then followed him to the land of dreams and magic. Here she visits the land of the dolls and the Snow Queen, where she meets all different types of snowflakes. She journeys to candy land eating sweet and delicious candy, coming upon beautiful flowers and the Sugar Plum Fairy. On Christmas Day young Clara reawakens to find herself back home, surrounded by her family.

Marius Petipa the ballet master to the czar of Russia, requested Piotre Tchaikovsky to write the score for the ballet. In composing the music, Tchaikovsky used many unusual instruments including the Celesta, which has the bell-like sound so familiar in the ballet. He kept the use of this instrument secret, fearing that someone would steal his idea before he was able to use it. As it happened no one stole it and the ballet went on to be one of the most famous ballets of its time.

The Legend of the Robin

When we think of Robins we think of the first warm days of spring. Surprisingly it is closely associated with the holiday season and is known as the "Christmas Robin"!

The male American Robin is distinguished by the bright red plumage on its breastbone, in contrast to the female which is duller in comparison.

The European Robin is the national bird for Britain.

And so the Legend finds this winged wonder in close proximity to Mother Mary and the Christ Child. Mary was trying keep herself and her infant warm from the dying embers of the fire within the stable. The night was bitterly cold and she appealed to the ox, donkey, horse or sheep. They all either refused or were of little use.

Robin heard the commotion and Mary's cry for help. He flew over to the stable and began flapping his wings continuously to bring the fire back to life.

He began dropping dry sticks into the fire and while doing so the flames rose and burned his breast. Undaunted by his injuries, he kept fanning the flames to provide enough warmth for the infant to sleep comfortably.

Mother Mary seeing his valiant efforts, thanked him, tenderly looking at his burns. She blessed him for his valour and selflessness, forever linking the red breast of the Robin to selfless service and Christmas.

Legend of the Babushka

Christmas is a time of joy, wonder and the celebration of family, friends and the exchange of heartfelt meaningful gifts. The tradition of gift giving was thought to begin with the birth of Christ and the gifts he received. Children figured prominently in this pleasing ritual.

The Russian version of St. Nicholas is *Babushka*, meaning grandmother and had been popular in old Russia, prior to the Russian revolution of 1917. Babushka, not unlike the North American Santa Claus, was known for gifting presents to good children, while they slept in their beds.

It all began with a story of an old woman who lived in a hut near crossroads, where many roads intertwined. She led a solitary existence, far from any villages or towns. But she was entertained by watching the passing of strangers using various modes of transport, converging and departing during the warm months.

In the harsh Russian winter, she often would feed birds, sharing the crumbs of her table. She was too old and frail to chop wood for her fire and too poor to buy candles to light her home. She sat alone, throughout the bitter cold, waiting anxiously for summer.

On this one frigid night, she was surprised to hear voices approaching her hut and the knocking on her door. Running to get what was left of her only candle, she peered curiously at the three men, standing at her door, dressed in rich garments.

They told her they were following a star, lighting their way to the birth of a child and invited her to join them.

She refused and after they departed, she regretted her decision to stay behind and set off after them in hopes of finding the three wise men.

Dressed in tattered woollens and carrying a basket with treats for this newborn, she walked from village to village, telling her tale and searching in vain.

She would eagerly study each child in hopes of identifying the much talked about Christ Child. Unsuccessful, she would depart, but not before placing a gift within each sleeping child's bed. Sadly she travelled and searched for years never finding Jesus Christ.

In modern day Russia this tale is often told and gifts are always left in the children's bed as they sleep, to discover the gift left by Babushka, upon awakening.

Legend of the Christmas Spider

Christmas originated with the beginning of Christianity over two millenniums ago. It has evolved over the centuries and the popularity of this winter festival has inspired many stories, superstitions and traditions, followed by many cultures across the globe.

There are many legendary characters associated with Christmas, one of them being the Christmas Spider!

This is a delightful story of a poor widow, who couldn't afford gifts, but wanted her children to derive all the pleasures of Christmas.

After sending all her children to bed, she ventured outdoors to cut down a tree and brought it inside the house. She then cleaned her entire home so that it was spotless. No cobwebs or dust were left. As a result all the spiders escaped to the attic to hide in safety.

She then decorated the tree with joy and abandonment, anticipating her children's happiness in the morning. Once done she was so exhausted, she quickly fell asleep.

The spiders, knowing all danger was removed, crawled down the stairs from the attic to see this decorated tree. But it was so huge and tall, that all the spiders could see was the decoration at the very top. Led by the oldest and wisest spider they began to climb the tree and as they did they left behind trails of white cobwebs.

The Christ Child upon seeing this, rightly felt that the mother would not be pleased at seeing cobwebs on her beautiful tree, which she'd worked so hard to decorate. And so touching the cobwebs, he turned them to silver and gold.

Upon awakening the family were delighted to see the tree aglitter in gold and silver. In celebration of this legend in modern times, people adorn their trees with tinsel and tuck an artificial spider within the branches.

The Legend of the Sage Plant

In today's modern world Christmas has become more of a business for financial gain and much has been lost in the true meaning of Christmas. It is important to act with generosity and kindness and share what little one possesses.

King Herod being a tyrant, cruel, believing in Judaism became threatened by the birth of the Messiah. He ordered his soldiers to massacre all male babies under the age of two years.

Angels hearing of this warned Joseph and Mother Mary and the baby Jesus fled Bethlehem.

Upon reaching Egypt no one would lend these strangers a hand. The long journey had taken its toll and they were exhausted. Joseph told Mary to rest, while he went in search of water. Alone with the babe, Mary heard approaching horses hooves and knew what lay in store for her and baby Jesus should they be captured. Helpless and frightened for her child's life, Mary asked a nearby rose bush for refuge. The Rose bush refused, fearing its beautiful blooms would be crushed under the horses' hooves. As Mary moved on to seek safety, the rose bush at this time developed thorns.

Mary approached a clove bush. She was not allowed to hide behind its branches either, and it is said the blooms developed an offensive smell from that time forth.

The sage bush, seeing Mary's plight, offered refuge and immediately the bush blossomed, sheltering Mary and Jesus from harm.

In gratitude Mary blessed the Sage bush, "Sage, oh holy Sage, many thanks for your good deed, which all will henceforth remember."

Since then the Sage plant has been hailed for its healing powers and its medicinal purposes. Highly fragrant, it is a common ingredient used in Christmas stuffing, delighting the tastebuds.

The Legend of Rudolph

A popular character, Rudolph the red-nosed reindeer is portrayed with a bright glowing red nose. Being Santa's most prized reindeer, he pulled the sleigh lighting a path, while Santa delivered gifts on Christmas Eve from house to house.

There are many variations on this theme, and the origin of Rudolph. Contrary to popular belief, Rudolph is actually a 20th century creation, which can be traced to a specific time and place.

Rudolph was invented and designed by a Montgomery Ward employee and copywriter, Robert L. May. He tested his design on his own young daughter, to gauge the level of appeal to children.

He was then asked to compose a story for a promotional gimmick. Soon the story was written with the reindeer as a hero. It is said that May combined the names of Rollo and Reginald to spell the name Rudolph. But Rudolph had a problem. His red nose was an affront to the general public, as red noses were associated with drunkards who drank large quantities of liquor. Despite that, the story and pictorial depiction was approved. Two million books of Rudolph were circulated during the 1940s.

After WWII Rudolph became a commercially printed comic and the the song "Rudolph the Red-nosed Reindeer", vocalized by Johnny Marks, became the best selling song of all times.

Thus heralds the career of Rudolph. However the Legend is told with a slight difference.

Rudolph was no ordinary reindeer. He was born to a well-to-do family and his red nose never caused embarrassment to his family and friends. He was a very responsible creature but had a few issues with self-esteem. Fortune was to shine down on Rudolph, for Santa's and his paths were about to converge.

It was on Christmas Eve while Santa was delivering presents in his sleigh all over the world, he noticed a red light emanating from one of the houses. Santa bumped into Rudolph by accident and believed that without the glow from Rudolph's nose, an accident would have surely befallen him while in his sleigh.

Santa not only chose Rudolph to be part of his team, but picked him to lead the rest of the reindeer, back to the North Pole in safety.

Santa was heard to say, "By you last night's journey was bossed. Without you we certainly would all have been lost!"

And so, regardless of Rudolph's origin, he and his story have become one of the most popular legends of all time. And will most likely be celebrated for many, many Christmases to come.

The Legend of the Holly

Christmas would be sorely lacking without the beautiful waxy leaves and red berries of Holly.

The Druids believed the holly leaves remained green to keep the earth beautiful, while all else lost its leaves. It was considered sacred because it bore fruit during the winter.

One would also have good dreams, if holly was hung above the bed.

In another part of the ancient world, Holly was connected to the Mythical King Saturnalia, patron of the winter solstice, and it was the scared plant of Saturn. During Saturnalia festivals the Romans would give wreaths made of holly to each other and adorn the statues of Saturn.

Centuries later Christians would celebrate Christmas and hang a branch of holly on their door to avoid persecution. As time wore on, Holly lost its pagan significance and became a symbol of Christmas.

It was thought that at the birth of Christ the Child a gift of Holly was given to him. He pricked his finger on the thorn and the Holly had a terrible vision of Christ's death and a crown of Holly adorned his head.

The Holly was ashamed of this vision, but Mother Mary forgave him. The berries being white, the Holly blushed with pleasure and the berries grew bright red.

And yet another tradition states that the green waxy leaves represent eternal life and the red berries represent the blood Christ shed for our salvation. The crown of thorns that Christ wore was made of Holly.

The Legend of Santa Claus

As adults we often forget the simpler joys of Christmas. The sparkle of a decorated tree and the pleasure of being allowed to place the star at the very top of the tree. As children we could hardly fall asleep on Christmas Eve, anxiously awaiting the sound of Santa's arrival with the eagerly anticipated toys we wished for and hoped to receive. That jolly little elf all dressed in red with a twinkle in his eye as he came down the chimney and ate the cookies and drank the milk set out especially for him. But all too soon we grow up and the magic of Christmas becomes far less the older we get. But the Legend of Santa Claus lives on in our hearts.

St. Nicholas was born to a wealthy, Christian family in Myra, in what is now known as Turkey. He was exceedingly kind and generous in nature and his benevolence knew no bounds. He became so well known, his generosity spread so far, he became the Bishop of Myra.

The contentment of his townsfolk was important to him, so he would travel at night to visit everyone and take the time to listen to all their stories.

It so happened that one evening upon passing a villager's home, he overheard their conversation with family members. Hard times had fallen upon these good people and in order to survive they would need to sell their three daughters into slavery or prostitution. Not being able to stand by and watch these unfortunate circumstances unfold, he tossed three bags of gold into the home as discreetly as possible. Tradition has it, he used the chimney for his deposit of gold.

Different cultures portray Santa in a variety of ways. His costume varies from country to country.

But since the 19th century, he is represented as a very spry but old man, with twinkling eyes, white flowing hair and beard. He is dressed in a red coat, pants and hat and accessorized with black boots, belt and mittens. He is seen to carry a large bag of jute filled to the brim with toys, to deliver to everyone across the globe on Christmas Eve, through the chimney. Some think he's a jolly old elf and lives for eternity.

Children are encouraged to write to Santa, indicating the toys they wish to own and play with. He even has his own address and postal code. How delightful! — Santa Claus , North Pole, Canada H0H 0H0.

The Legend of the Drummer Boy

Most legends of Christmas are well known. But there is one that is oft forgotten and left untold. Other then wise men and shepherds who visited and brought gifts for the baby Jesus, there was also a solitary boy. A boy with a drum carrying a profound and deeply felt message.

There was once a boy named Zachary, who lived in a village in Jerusalem. One year for his birthday, his parents bought him a drum. Zachery loved parades and hoped to one day be part of one.

Late one night he was awoken by a loud sound. Jumping out of bed and looking out his window, Zachery realized it was a parade.

Seeing his chance, he grabbed his drum and joined the rest of the participants. Drumming his drum loudly and disturbing the citizens from their sleep, he was told to stop making so much noise.

He ignored the complaints and kept drumming. As he was walking he noticed that there were three men, richly dressed and riding on camels led by slaves. Bemused, he was wondering where everyone was going, until he saw a bright star in the sky shining down on a stable. He could catch conversations here and there about a baby that had been born.

Once there, everyone presented Baby Jesus with gifts.

Largely ignored and unnoticed, Zachery felt a sadness at not having brought a gift, and once everyone had left, he did the only thing that was left to him. He played on his drum.

For the first time and unlike the response to other gifts presented to him, the Christ Child turned in acknowledgement and smiled at Zachery, on this very special day.

Zachery no longer felt sad, for he knew he had given the greatest gift of all; the gift of love.

We are all familiar with the Christmas carol called "The Little Drummer Boy" in honour of Zachary and his drum. And "the ox and lamb kept time pa rum pum pum pum!"

The History & Traditions Of Advent

Advent means "coming" as in the coming of the birth of baby Jesus. Yet other Christians consider "coming" as in the second coming of Jesus, where he will stand in judgement onto the world.

The advent season encompasses four Sundays or four weeks before Christmas and Advent can only begin on December 1st if Christmas Day falls on a Wednesday. Therefore, in 2017 Advent begins on November 27th. Because the day Advent begins changes from year to year, the length of the advent season changes also.

Although advertisers and retailers are displaying, seemingly earlier each year, Advent still brings peace, focus, joy and the observances of traditional customs. It is a time for quiet moments of reflection lighting the candles within the advent wreath. Children and adults alike find great pleasure in anticipation of Christmas Day with the countdown on the Advent Calendar.

It is most likely that the observations of Advent started during the 6th century. Originally it was a time when people converting to Christianity, would ready themselves for baptism.

During Medieval times, Advent began on November 11th, the feast of St. Martin, a time for fasting and prayers in preparation for the second coming. Some refer to this period as the "Lenten" season.

In the last half century, Advent has become a time of anticipation for the nativity on Christmas Day.

Advent wreaths have their beginnings in Northern Europe, when folk would arrange evergreens in a circular fashion and light the candles within. The evergreens in a circle symbolized the continuity of life and the candlelight gave comfort and hope in the darker days of winter and the anticipation of spring. This practice spread throughout Europe and North America by the 16th century and the wreaths were fashioned much the same as we do today.

Customarily an Advent wreath holds four candles: three purple and one rose. The purple is lit on the 1st, 2nd and 4th Sunday symbolizing hope, peace, and love, and the Rose candle is lit on the 3rd Sunday meaning joy. Yet others will add a fifth white candle, lighting it on Christmas Day, reminding us of the birth of Jesus and the angels.

Advent Calendars found their origin in Germany during the late 1800s and soon spread throughout Europe and North America.

Initially images derived from the Hebrew Bible were depicted on each day. Today advent calendars have less to do with the bible and much to do with the fun of counting down to Christmas. Each day has a drawer which opens to reveal chocolates, candy or small gifts and in the past few years advent calendars have become more imaginative and colourful, encouraging some to fashion their very own personalized calendar, expressing their individual tastes and styles.

The History and Legend of the Amaryllis

Amaryllis comes from the word *amarysso*, meaning "sparkling" in Greek.

With the beauty of these flowers it's no wonder it's not only becoming a favourite at Xmas, but a tradition as well. Taking its place alongside the more popular poinsettia, it is a symbol of pride. Being unique and highly treasured, it serves to bring the beauty of nature indoors, brightening our hearts on cold winter days.

Botanists believe the Portuguese first brought these bulbs to Europe during the 16th century, distributing them to the wealthy patrons that funded their exploration trips around the world. Explorers from Italy, Portugal and Spain often travelled to far off places such as the Canary Islands and Madeira. Importing the Amaryllis rivalled the sugar cane and slave trade. This beautiful plant was also discovered by a German physician in the Andes Mountains, Chile in 1828.

Initially the amaryllis was referred to as the "lily". The Portuguese called it the "St. Joseph's Staff", legend being that upon seeing the Virgin Mary, his staff turned into bright red blooms, indicating to him she was his future wife.

Another legend has a beautiful but very shy shepherdess falling deeply in love with a man, Alteo, who would not return her love. He preferred his garden over her.

Despairing of ever gaining his attention, she sought out the advice of an oracle, who gave her a golden arrow. She was to prick her heart each day, for 29 days in front of Alteo's home.

On the 29th day, the blood she shed from her heart, turned into beautiful red flowers. At that Alteo noticed her and fell in love, naming her Amaryllis.

And unlike so many legends, this has a happy ending.

History of the Feather Tree

The feather tree originated in Germany during the 1800s. People were environmentally concerned about the deforestation of their land and subsequent waste of trees after the Christmas season was over.

The first feather tree was brought to the US by a German immigrant and the tradition caught on.

These trees were fashioned using goose feathers, stripping the centre and attaching a wire. It was then fastened to a centre pole, which was held within a square or round base, resembling the German buckets that were used for the evergreen trees.

The branches were widely spaced to allow room for candles without burning the branches and to allow the Christmas ornaments to be displayed at an advantage.

Today these authentic feather trees fetch an exorbitant price on the auction block and are highly desirable by collectors.

After WWI they were no longer hand-crafted and production feather trees started to appear on the market.

Sears Roebuck was the first to offer feather trees in their catalogue. They were easy to ship as they folded up like an umbrella. Later they were produced with lights attached.

Today retailers offer a large variety of feather Xmas trees primarily in the pyramidal shape, in all colours and several different types of feathers. The prices range from a few dollars to hundreds. Before investing in an expensive feather tree, make sure they are made of real feathers and not paper or plastic.

The Twelve Days of Christmas

We've heard the song "The Twelve Days of Christmas" and in modern times it has become very popular. Different renditions exist, some very funny and satirical while others hold to the original melody and prose. But knowing the whys and when of this song will have you listening to it with an entirely different perspective.

The twelve days of Christmas was created during the 16th–18th centuries in England to protect people who believed in the doctrines of the Catholic Church. During that time Catholicism was outlawed and religious persecution was feared by all who practised it.

It was meant as a secret catechism written in code, so it could be sung in public without fear of reprisals, arrests and certain death. Each verse refers to specific teachings and doctrines of the church.

The twelve days of Christmas are observed between December 25, the birth of the Christ Child and January 6th, the Epiphany. Christians commemorate January 6th as the arrival of the 3 Magi (Wise Men) and the revelation of Christ as the shining light over all.

The following is an explanation of each verse in code.

1. Partridge in a pear tree; stands for Jesus and the tree is his crucifixion on the cross.

2. The two turtle doves represent the Old and New Testaments.

3. The three French hens stand for faith, hope and love.

4. The four calling birds are the four gospels.

5. The five gold rings represent the first five books in the Old Testament, referred to as the Pentateuch.

6. Six geese a-laying are the six days of creation.

7. Seven swans a-swimming are the seven gifts from the Holy Spirit.

8. Eight maids a-milking represents the eight beatitudes.

9. Nine ladies dancing are the nine fruits of the Holy Spirit.

10. Ten lords a-leaping are the Ten Commandments.

11. Eleven pipers piping refer to the eleven apostles.

12. Twelve drummers drumming refers to the twelve doctrines in the Apostles' Creed.

I hope that after reading this one will still find joy in the song "The Twelve Days of Christmas".

Boxing Day, December 26

Today Boxing Day is a opportunity for many people to take advantage of the sales after Christmas Day. Or to visit those friends and family one did not see during Christmas.

But many prefer to stay at home with their family, eating leftovers, watching sports events or just resting and relaxing after the hectic days of the holiday season.

Boxing Day is so named and it began during the Middle Ages in England. Although the facts surrounding this day are obscure, historians believe that because servants had to work on Christmas Day, they would take the following day off to visit their families. Employers would often present them with gift boxes!

Another theory holds that boxes were placed within churches for the deposit of coins for the poor. On Boxing Day, this bounty would be opened and the contents distributed amongst the needy.

The custom evolved to present gifts to others, who had performed a service either out of kindness or professionally for an individual, the previous year.

The Feast of St. Stephen is also celebrated on December 26. St. Stephen was a deacon of the Christian church, ordained by the Apostles. He attended to the poor and the widows and his sermons were so well received and his devotion so strong to Christ, that a mob gathered and stoned him to death. His last dying words were to ask God to forgive his persecutors.

In 1871 Boxing Day was declared a bank holiday. Bank doors were closed, as well as government offices and postal carriers were exempt from work on that day.

Legend of the Mistletoe Bride

Most legends stem from actual accounts and exploits of people centering around their lives, that become more embellished with the the retelling of the tale.

The poem "The Mistletoe Bride" was penned by Thomas Haynes Bailey in 1830, and it was thought he got his inspiration from the poem "The Mistletoe Bough" written by Samuel Rogers in 1822. As a tribute to this legend Bailey's poem was used as lyrics in a song created by Sir Henry Bishop. It caught the imagination of the populace and was sung across both sides of the Atlantic, during the 19th century.

It was thought that the setting was Minster Lovell Hall, the home of Lord Lovell, where a wedding took place. It was during the celebration that the bride sought surcease from the occasion and suggested a game of hide 'n' seek. While all the guests scattered to do her bidding, she went up to the attic and found an empty chest, large enough to hide in. It also had a spring lock and when she climbed in to lie down within it, the lid shut and locked, imprisoning her within. All guests were found and accounted for except for the bride. Although thoroughly searching the grounds and the hall she was not to be found. Until years later she was discovered inside as a skeleton in her wedding-dress shroud.

It became a celebrated myth and many of the neighbouring halls lay claim to its location. However, if there was any truth to this tale, the most likely location would have been Lovett Hall and although it lies in ruins today, many claim it is haunted. Alas in its decrepit state, the attic no longer exists but the retelling of this legend remains.

Over the centuries many versions of the bride's demise existed but with a far happier ending. The bride was found and she was restored back to life with … what else but mistletoe! Merry Christmas.

The Mistletoe Bough

The mistletoe hung in the castle hall,
The holly branch shone on the old oak wall;
And the baron's retainers were blithe and gay,
And keeping their Christmas holiday.
The baron beheld with a father's pride
His beautiful child, young Lovell's bride;
While she with her bright eyes seemed to be
The star of the goodly company.
Oh, the mistletoe bough.
Oh, the mistletoe bough.

"I'm weary of dancing now," she cried;
"Here, tarry a moment—I'll hide, I'll hide!
And, Lovell, be sure thou'rt first to trace
The clew to my secret lurking-place."
Away she ran—and her friends began

Each tower to search, and each nook to scan;
And young Lovell cried, "O, where dost thou hide?
I'm lonesome without thee, my own dear bride."
Oh, the mistletoe bough.
Oh, the mistletoe bough.

They sought her that night, and they sought her next day,
And they sought her in vain while a week passed away;
In the highest, the lowest, the loneliest spot,
Young Lovell sought wildly—but found her not.

And years flew by, and their grief at last
Was told as a sorrowful tale long past;
And when Lovell appeared the children cried,
"See! the old man weeps for his fairy bride."
Oh, the mistletoe bough.
Oh, the mistletoe bough.

At length an oak chest, that had long lain hid,
Was found in the castle—they raised the lid,
And a skeleton form lay mouldering there
In the bridal wreath of that lady fair!

O, sad was her fate! —in sportive jest
She hid from her lord in the old oak chest.
It closed with a spring! —and, dreadful doom,
The bride lay clasped in her living tomb!
Oh, the mistletoe bough.
Oh, the mistletoe bough.

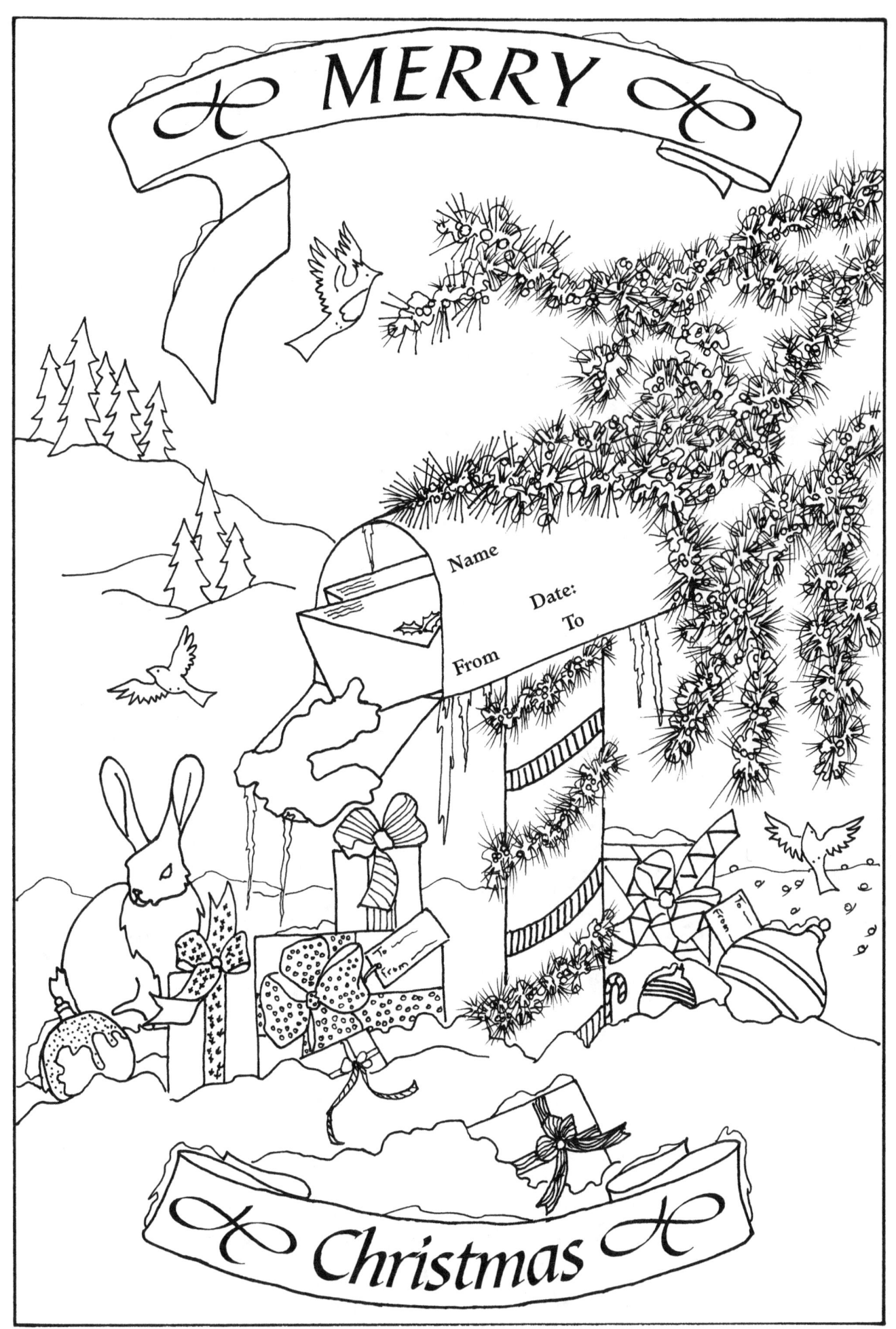

1. DESIGNATION PAGE

DECEMBER 1

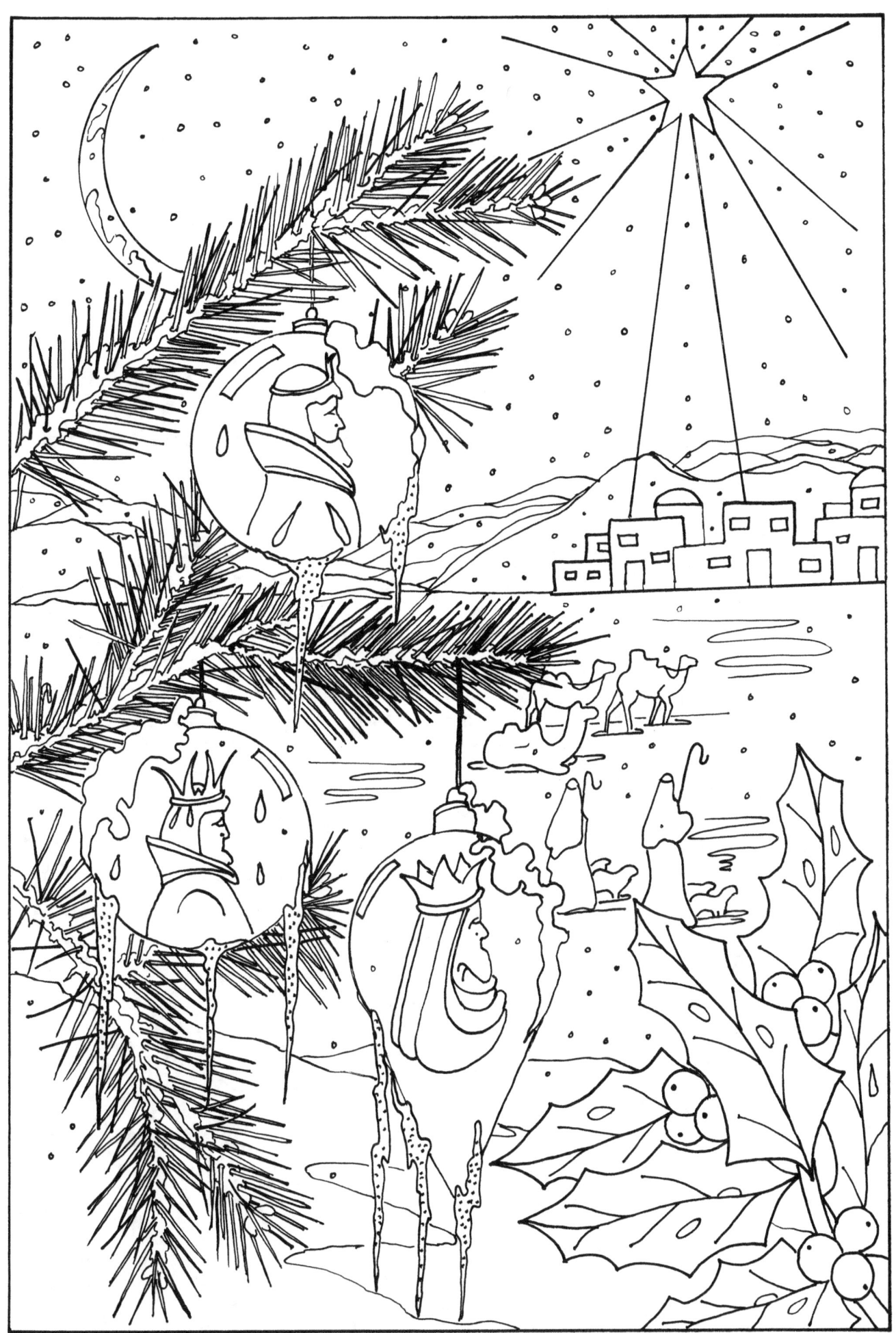

2. A Star Is Born

DECEMBER 2

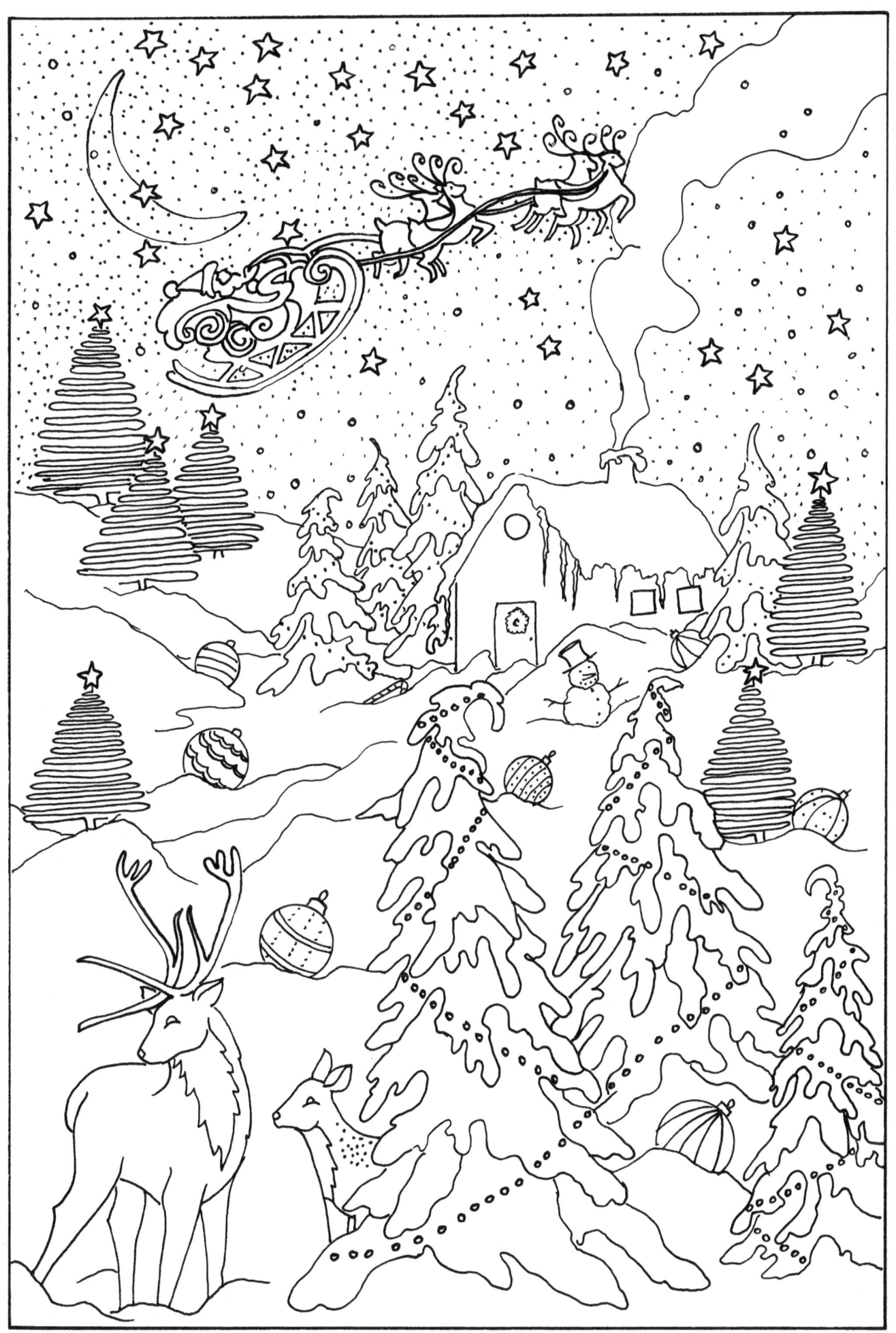

3. WINTER WONDERLAND

DECEMBER 3

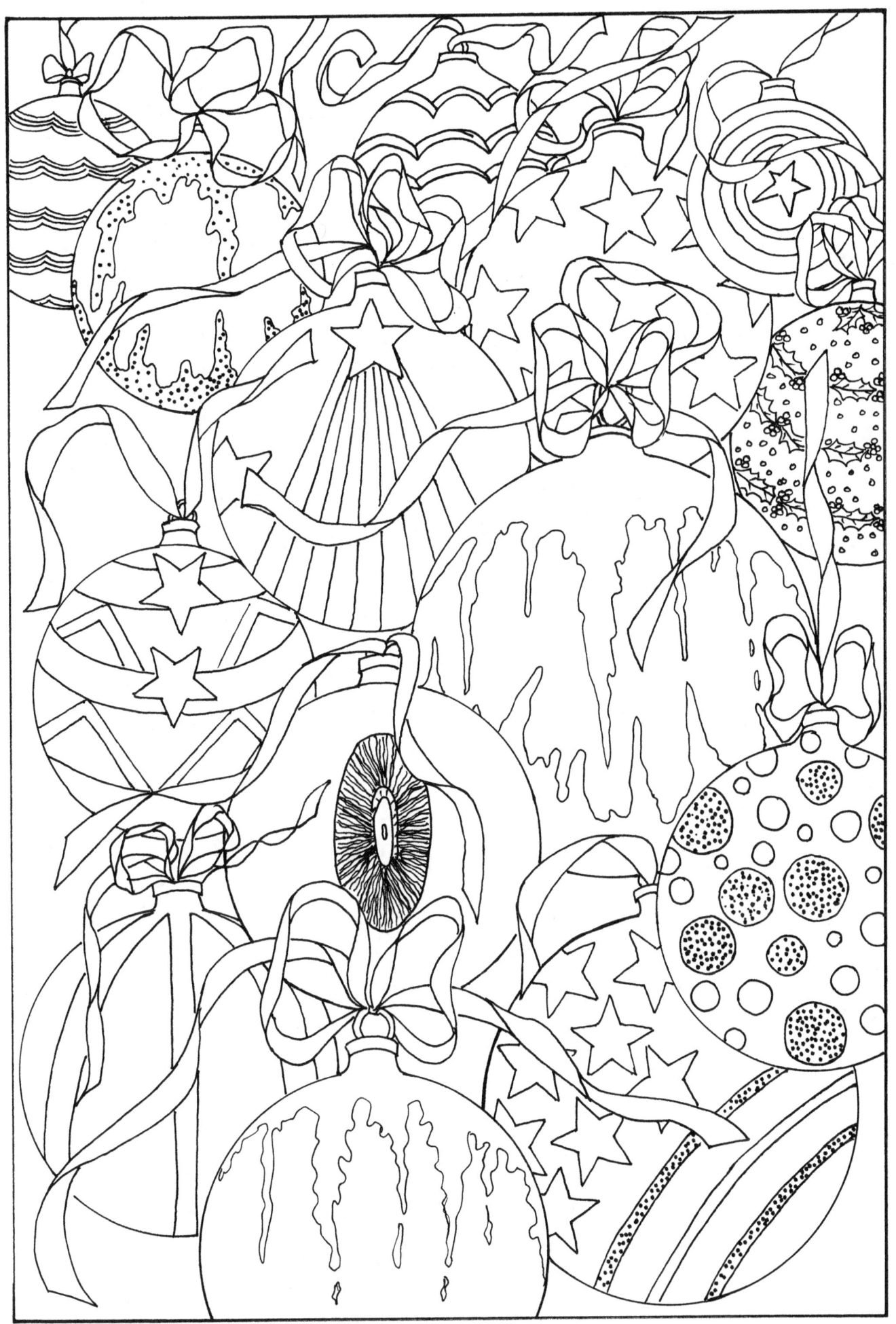
4. All Dressed Up

DECEMBER 4

5. Trinity

DECEMBER 5

6. Christmas ... Where the Home Is

DECEMBER 6

7. A Framed Ornament

December 7

8. Partridge in a Pear Tree

DECEMBER 8

9. OH CHRISTMAS TREE

DECEMBER 9

10. Christmas Buddies

DECEMBER 10

11. On Its Way

DECEMBER 11

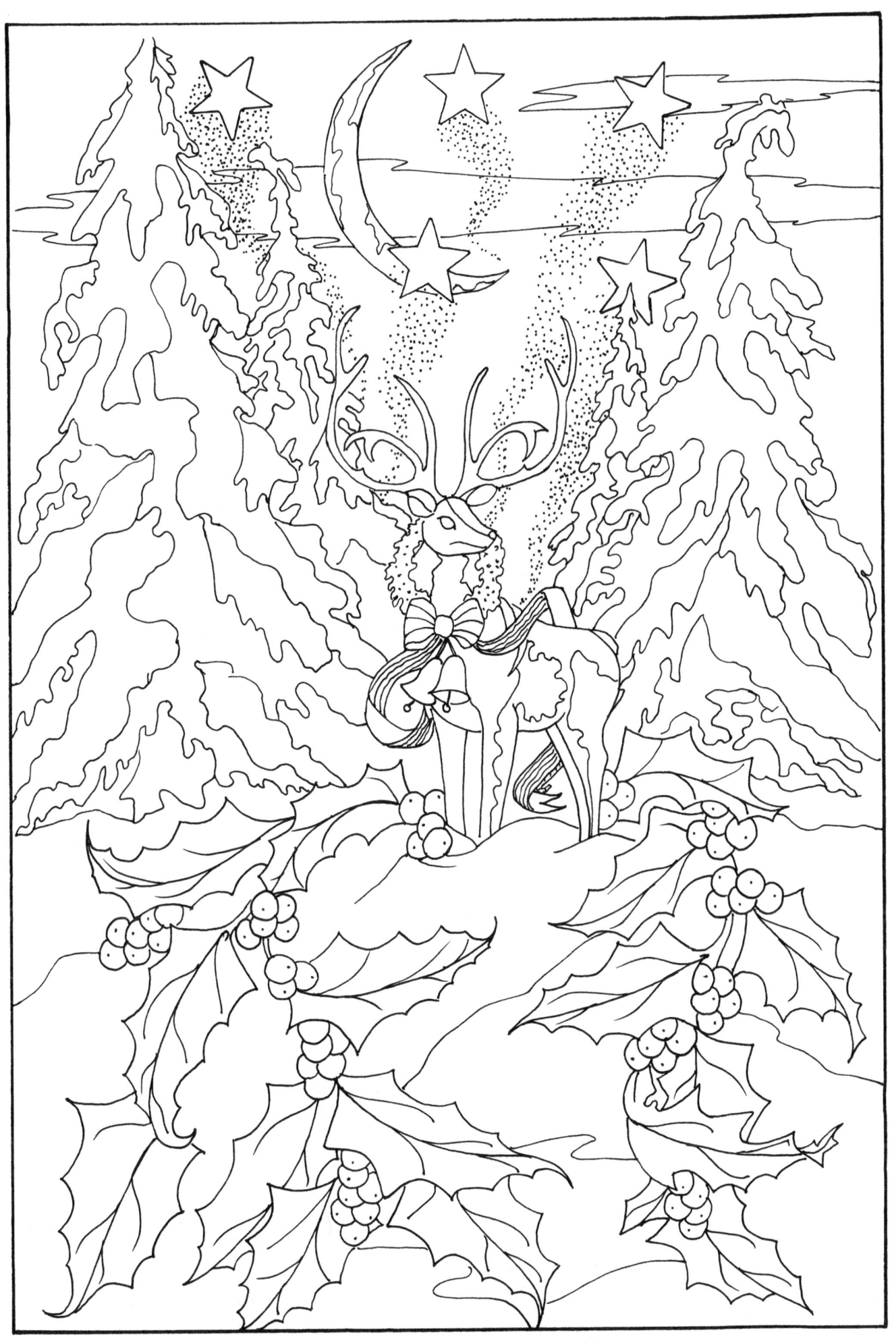

12. Majesty of the Winter Woods

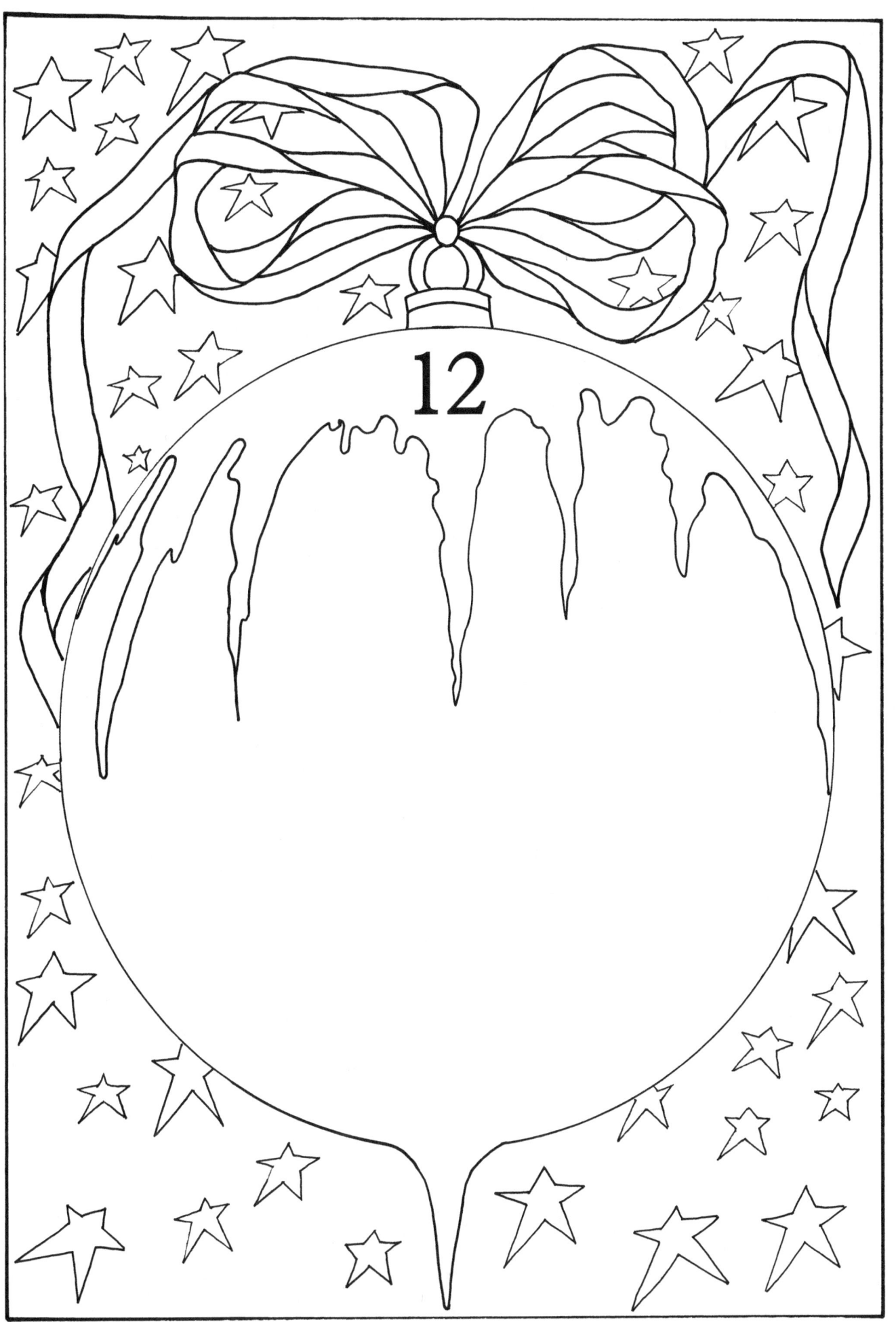

December 12

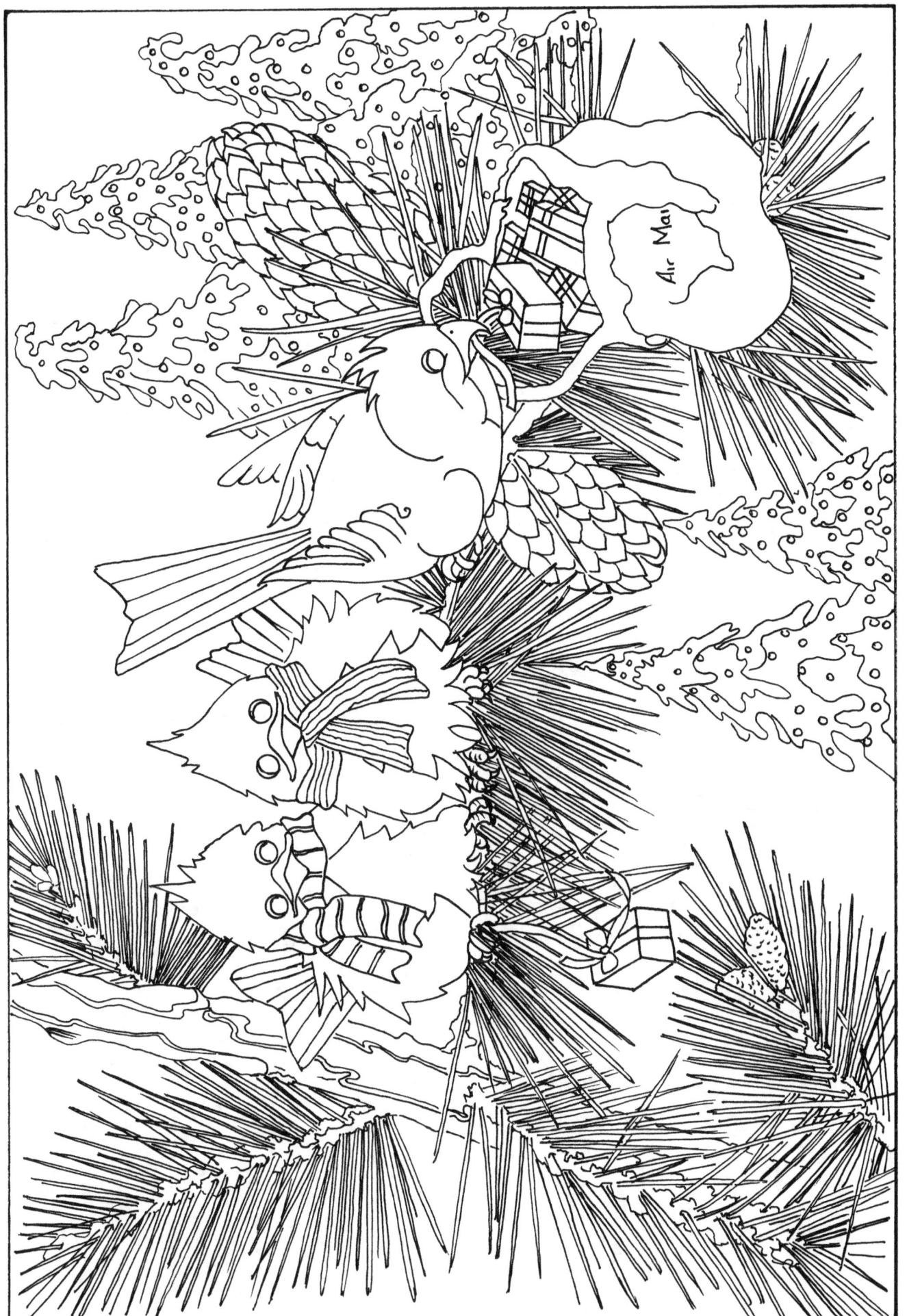

13. Distributing the Goods

DECEMBER 13

14. Frosty Companions

December 14

15. Christmas Siblings

December 15

16. A Message from the Cardinals

December 16

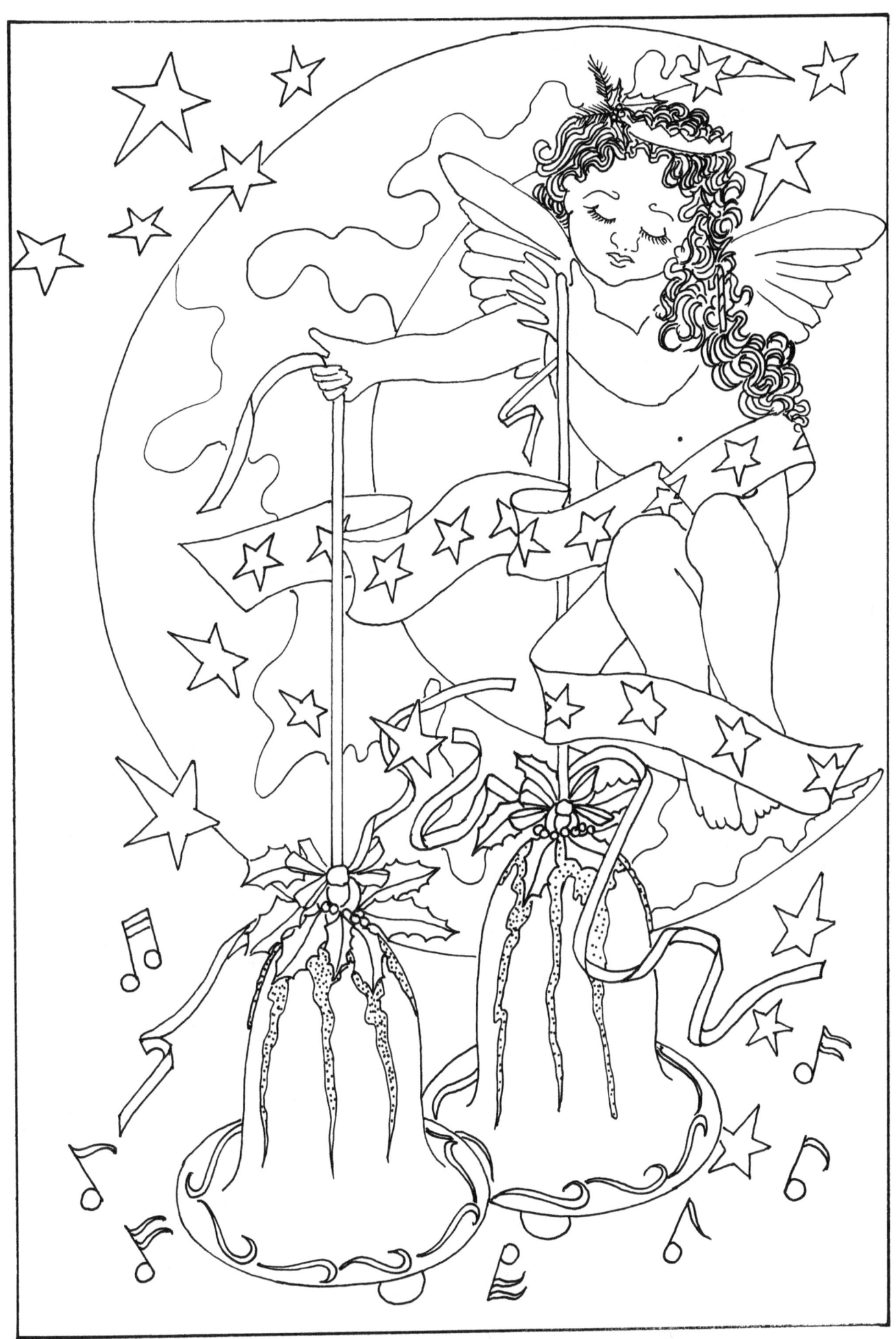

17. BELLS WILL BE RINGING

DECEMBER 17

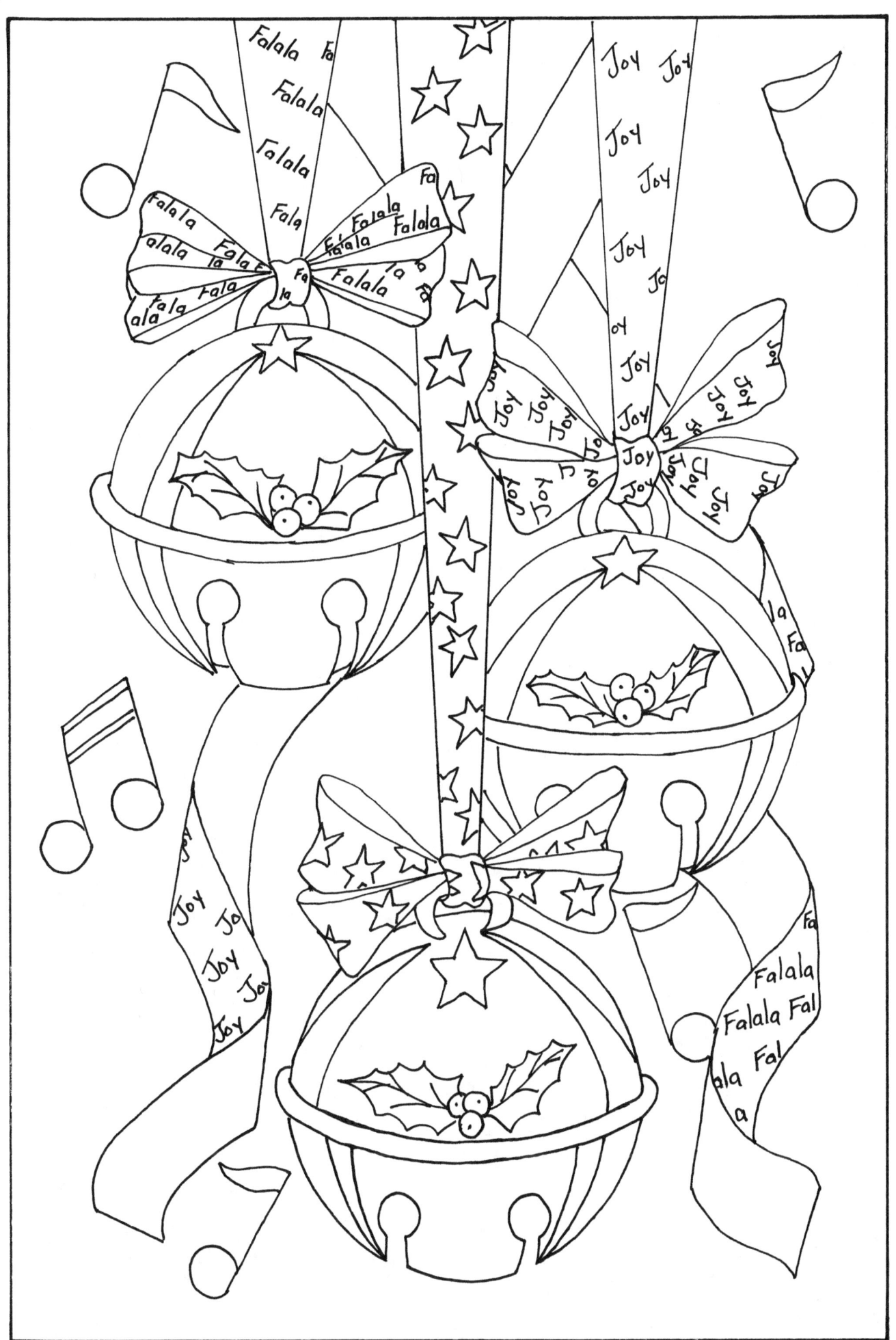

18. MUSICAL CHIMES

December 18

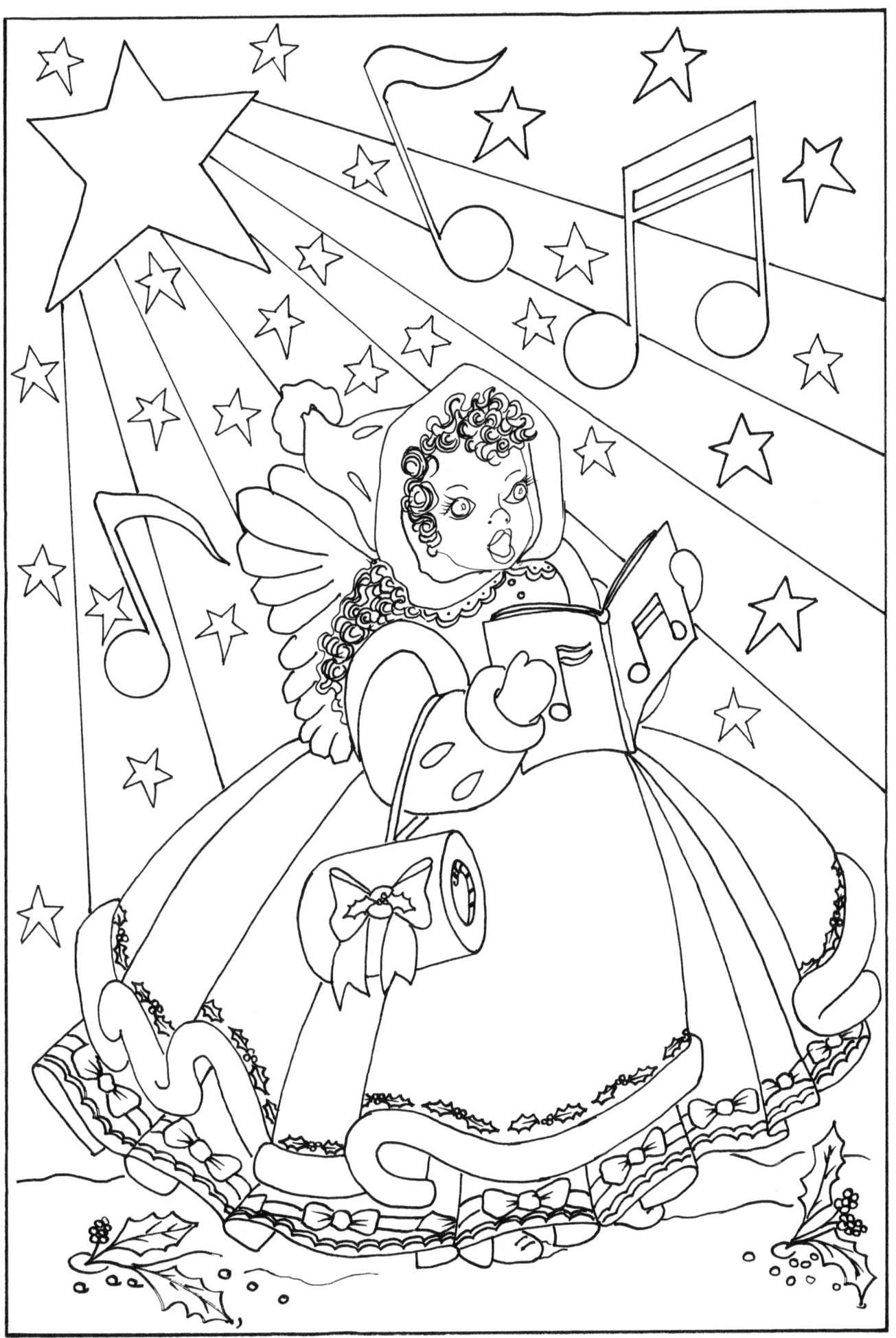

19. ANGELS IN OUR MIDST

December 19

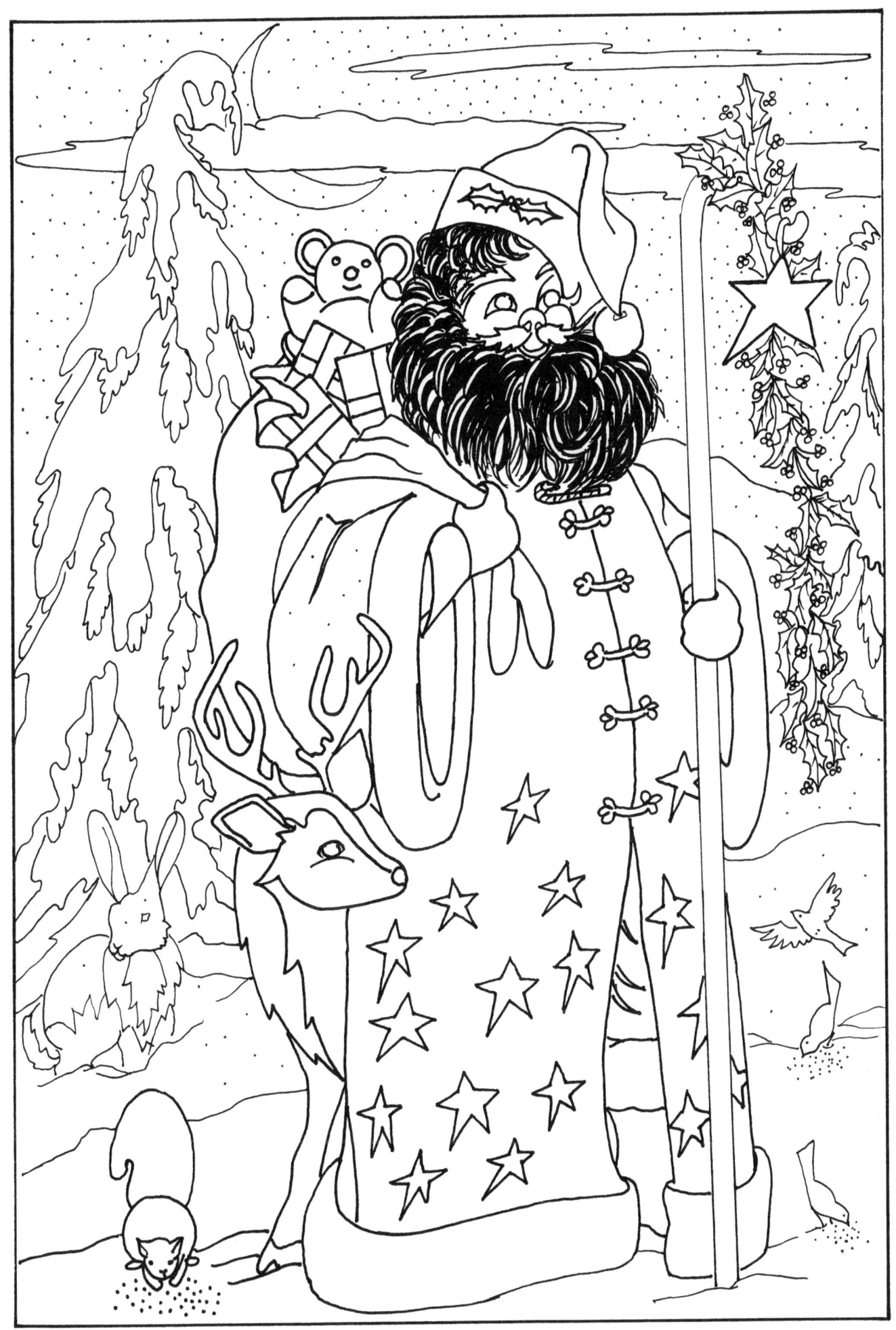

20. FATHER CHRISTMAS

DECEMBER 20

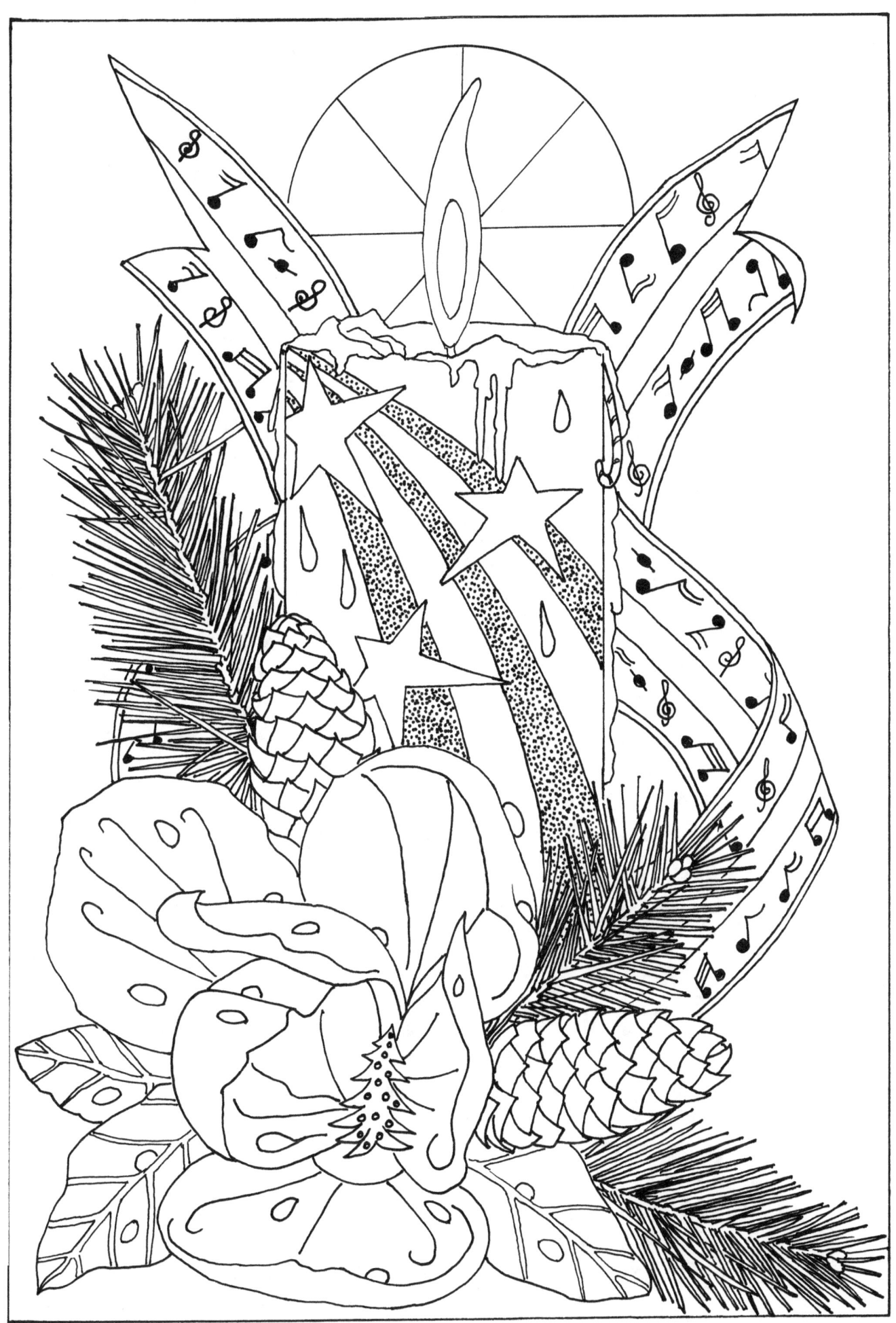

21. A Christmas Magnolia

DECEMBER 21

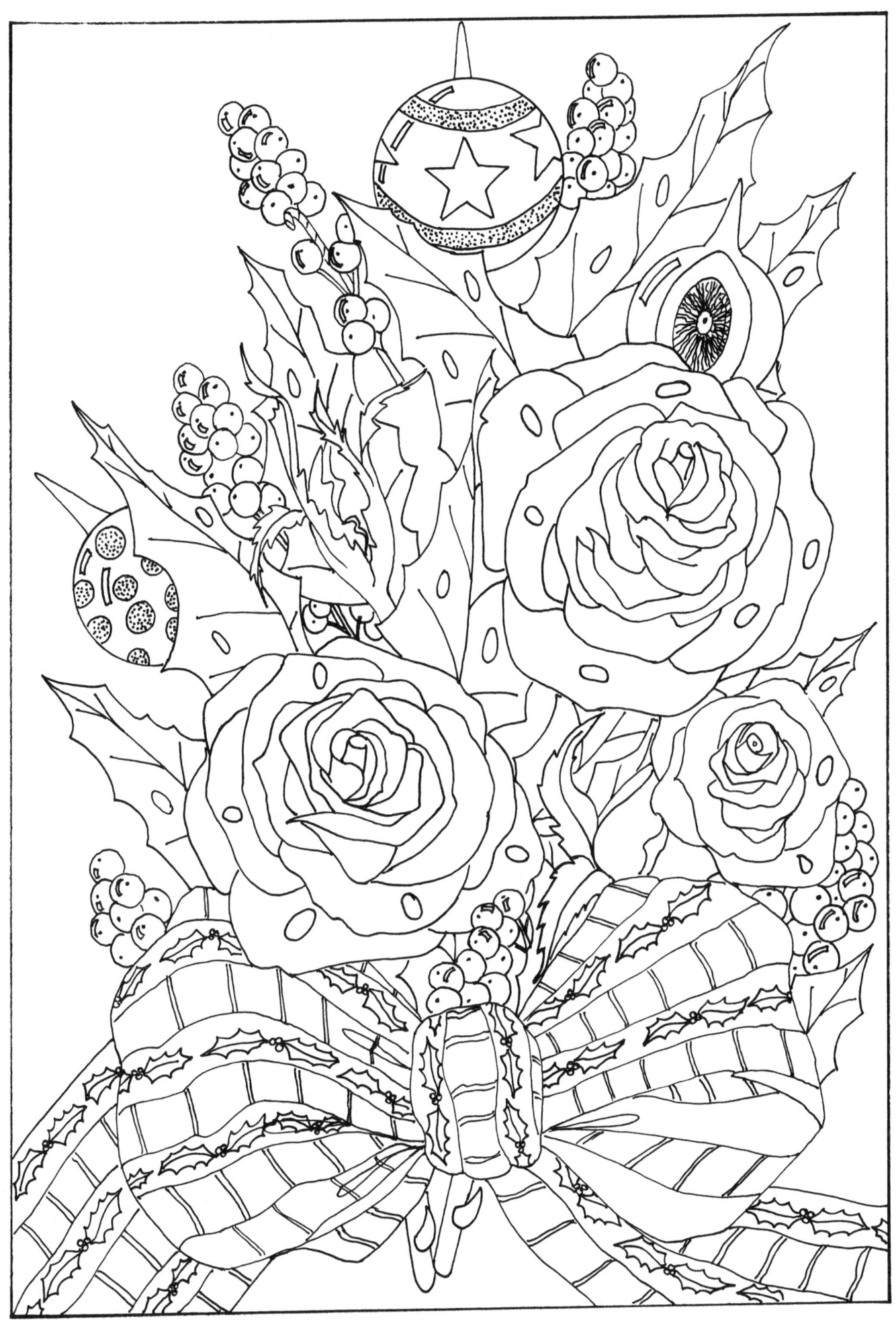

22. THE LEGENDARY CHRISTMAS ROSE

DECEMBER 22

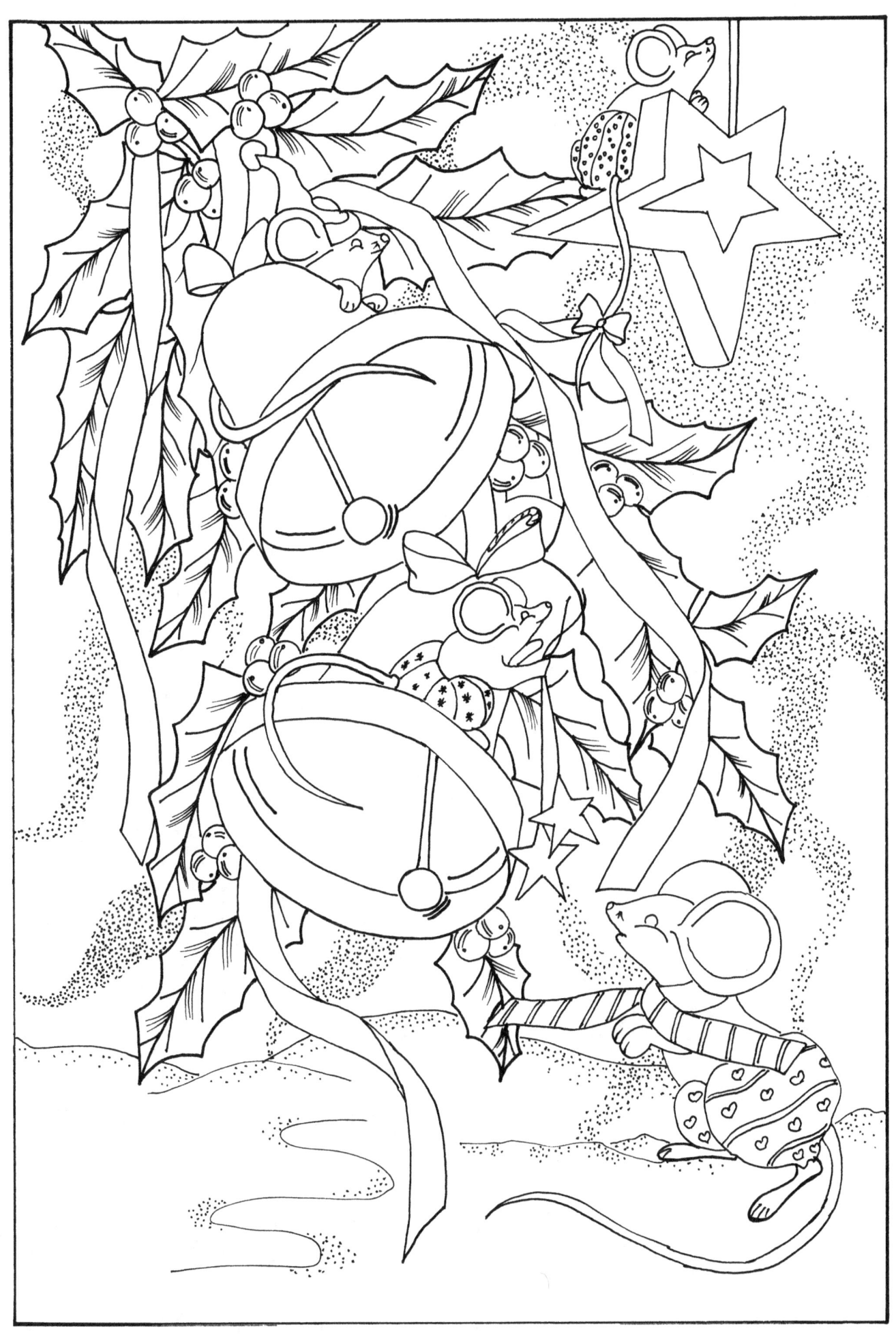

23. DING DONG: A CHRISTMAS SONG

December 23

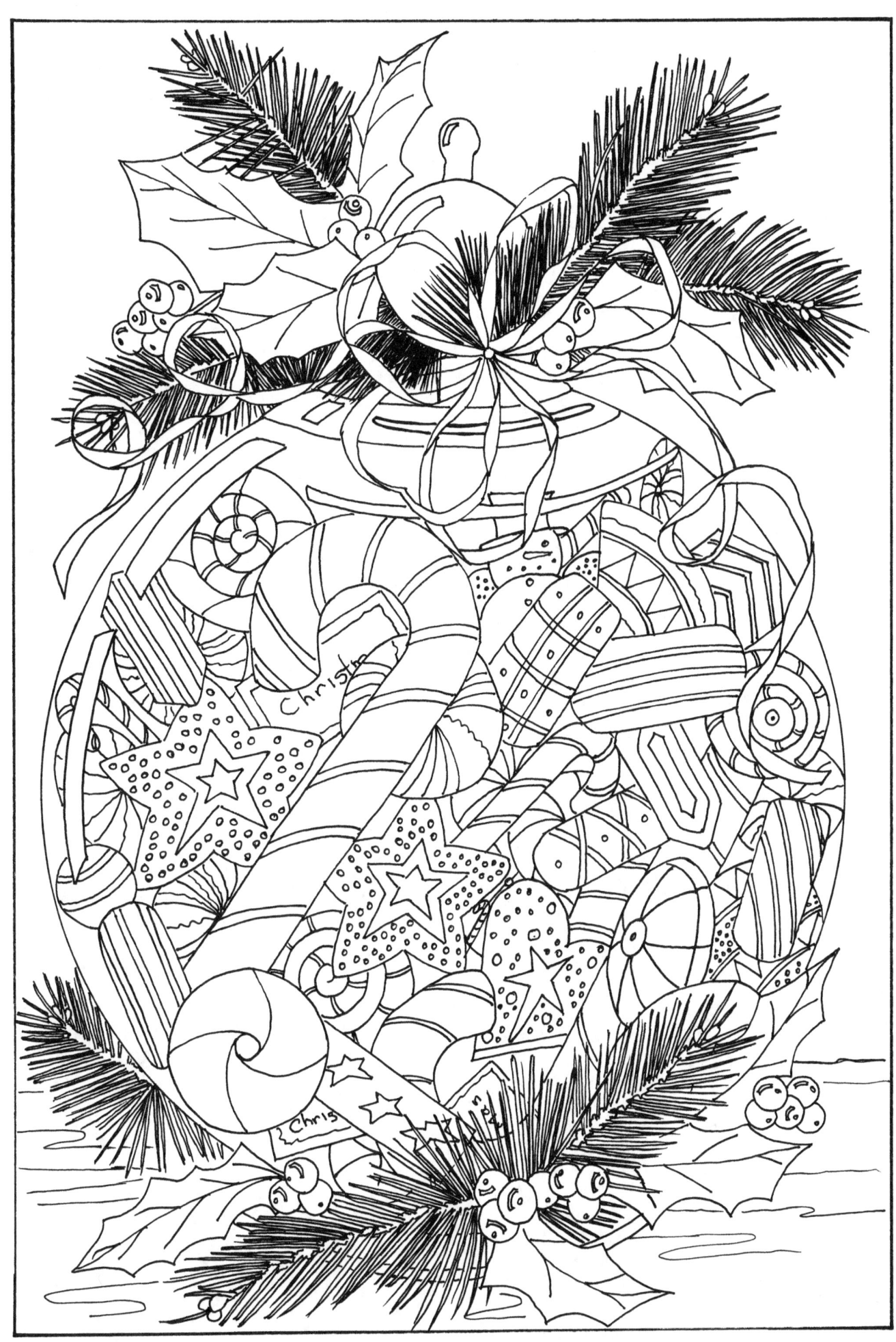

24. Goodies Behind Glass

DECEMBER 24

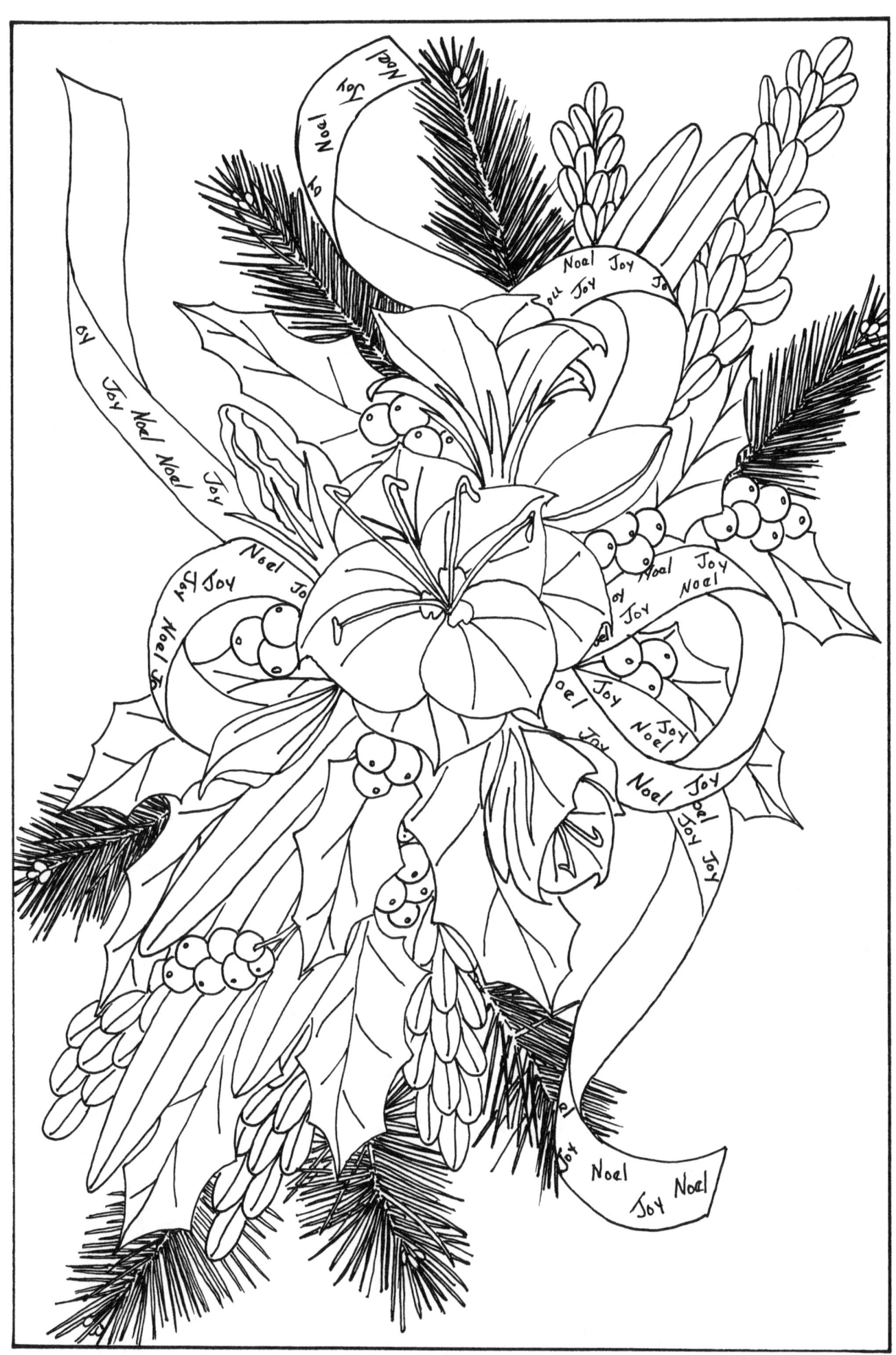

25. A "Sparkling Amaryllis"

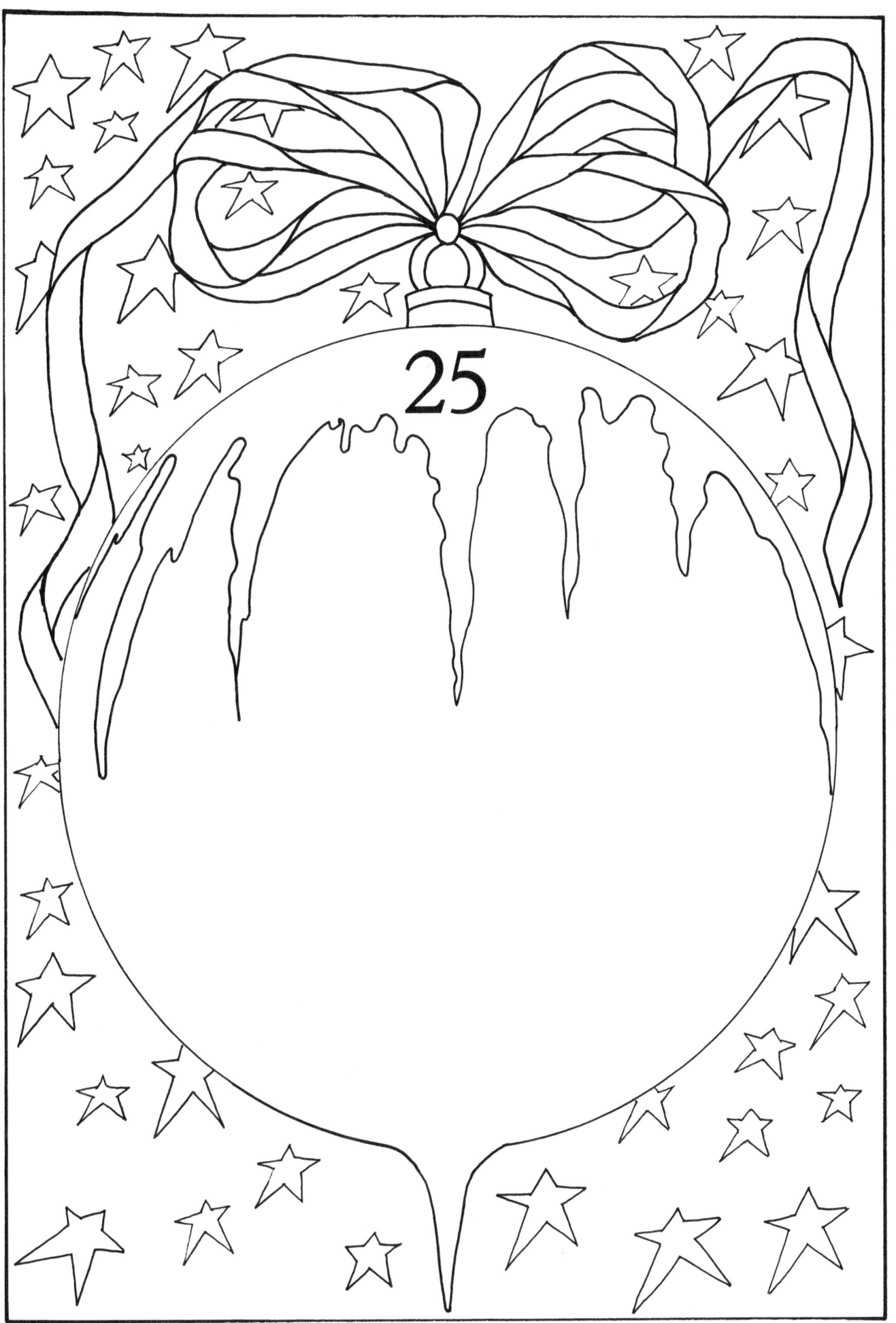

DECEMBER 25

Notes

Reminders to Myself